LIVING

WITH

AIDS

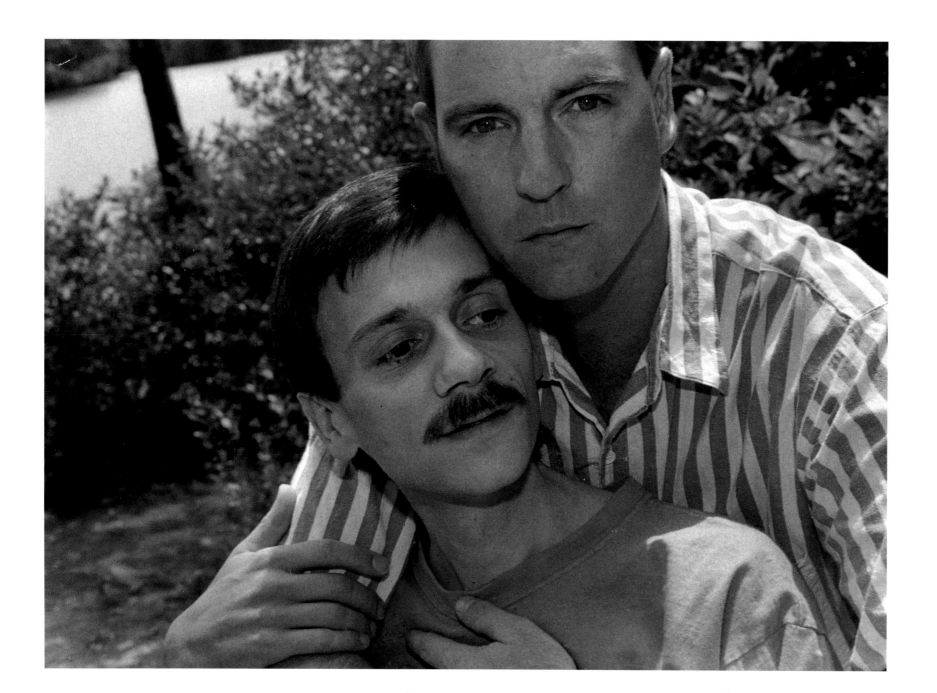

LIVING
WITH
AIDS

A PHOTOGRAPHIC JOURNAL

Sal Lopes

INTRODUCTION BY VICKI GOLDBERG

PUBLISHED IN ASSOCIATION WITH THE CHRYSLER MUSEUM

A BULFINCH PRESS BOOK LITTLE, BROWN AND COMPANY BOSTON • NEW YORK • TORONTO • LONDON

FIRST EDITION

Designed by Germaine Clair

This project was supported in part by a grant from the National
Endowment for the Arts, a federal agency.

Frontispiece – Buddies: Thom and Alan

ISBN 0-8212-2081-0
Library of Congress Catalog Card Number 93-86168

Bulfinch Press is an imprint and trademark of
Little, Brown and Company (Inc.)
Published simultaneously in Canada by
Little, Brown & Company (Canada) Limited.

PRINTED IN ITALY

Contents

Foreword

Sal Lopes is a remarkable photographer and an extraordinary person. To create this book he could not be merely one or the other. By necessity, he must be both. The compassion that Lopes feels for his subjects is evidenced by his photographic treatment of them. He steadfastly refuses to portray his subjects indelicately for the sake of a striking photograph. It is this ideal combined with the ability to create a powerful and moving body of work that distinguishes Lopes from the vast majority of photographers.

The photographs in this book reveal Lopes's uncommon finesse in his engagements with people. Rather than furtively taking a picture, Lopes spends time talking to his subjects, telling them about his project. He develops a rapport, an intimacy, and makes a sensitive portrait. His compelling portraits made at the AIDS Memorial Quilt are compassionate examinations of a stranger's psyche.

Making photographs of the Buddies required developing a more extensive rapport, with his subjects, although time was sometimes severely limited. Having gone through Buddy training himself, Lopes had some common ground with his subjects but still had to gain their trust – trust not only to allow themselves to be photographed but to have their inner thoughts recorded and transcribed and ultimately printed for all to see. When schedules and lifespans permitted, Lopes returned for additional photographic sessions.

The photographs of the Boyce Family represent yet another issue – an adopted child with AIDS and the loving care she received in the home. The details of domestic life become a chronicle of compassion in this heartfelt extended photo essay.

These diverse elements combine to become an inspiring examination of the human struggle with this deadly virus. Rather than a morbid chronicle of dying, Lopes has given us a positive and uplifting account of what it is like to *live* with AIDS. For those affected by AIDS, this book can be a catalyst for healing; for those whose lives are personally untouched by AIDS, a meaningful and educational experience.

This book is published in conjunction with an exhibition of the photographs at The Chrysler Museum. The exhibition will tour for several years. It has been an honor for me to have worked on this project with Sal Lopes. I thank him for his trust and for allowing me the privilege of becoming so deeply involved in this poignant meditation on the relentless spirit of humanity.

Brooks Johnson
Curator of Photography
The Chrysler Museum

Preface

In the summer of 1988, I photographed the AIDS Memorial Quilt in Boston. I had been deeply affected by the AIDS epidemic and felt a responsibility to photograph. Because of my previous work at the Vietnam Veterans Memorial, there seemed to be a photographic familiarity in shooting at the Quilt, but there were no thoughts of a project at that time. Present at the Quilt were the raw emotions of loss, grief, and friendship. How could I record these emotions on film to achieve the sense of tension that I felt? And how would I convey intimacy within something so vast? In the beginning, I always have more questions than pictures.

After several visits to the Quilt, I felt a need to be closer to people with AIDS. I read about the Buddy Program at AIDS Action Committee in Boston and was drawn to the photographic possibilities of two people brought together because of AIDS. In December of 1989, I took the Buddy training to understand these relationships better. It was now evident that a project was taking shape: in addition to their portraits, buddies would make tape recordings if possible, while some submitted journal entries. These would be used later as text for the book.

Early in the process, I received a call from someone I had just photographed asking how the film looked. I answered saying it was fine and that contact sheets would be ready in a few days. He passed away the next morning. From that point, I worked with a sense of urgency and treated each session as though it were my last chance, as often it was. I would not always have the luxury of knowing my subject. I shot as often as the limitations of time and medical circumstance would allow. A picture sequence often worked better than individual images. It gave a sense of action to an inherently static scene and offered more information about the dynamics of the relationship. The pictures reflect moments in time and relationships based on trust, kindness and honest communication.

While still photographing Buddies and the Quilt, I realized that, thus far, all my photographs had been about adults. I wanted also to photograph children with AIDS in a family environment, and, as luck would have it, I met the Boyce family in the summer of 1991. Brianna, one of four adopted children, had AIDS. Here I had the time, almost two years, to observe the art of John and Sharon's parenting and how life was made as joyous as possible. I photographed what impressed me most – the love and respect they had for one another and how this integrated itself with home care for Brianna.

I wanted a body of work that is life affirming. I am humbled by the strength, courage, and spirit of the people in this project and am very thankful for their trust. With some, I shared their final moments and, for me, this was an extraordinary gift.

Acknowledgments

There were many people who, through their generosity, support, love, and trust, helped make this book a reality. I wish to thank Ginny Hamel, my first contact at the Buddy Program, for her initial faith. She gave me a clearer understanding of the program and the people I was about to photograph. Nancy Silverman was coordinator of the program during most of the work. She made the initial contacts for most of the assignments portrayed in the Buddy section and had the confidence that this would be worth the incredible effort (almost four years), and I am grateful for her perseverance. Because of his courage and commitment, David Martin was an inspiration to many of us. As assistant coordinator, he facilitated many of the assignments in this book. He was totally dedicated to the Buddy Program. Later, when he himself was diagnosed with AIDS, he asked for a Buddy.

There have been many people that offered advice, support, inspiration, and friendship, during this project. I am especially grateful to Bill and Alletta Cooper, Richard West, Helen Levitt, Mary Ellen Mark, Phil Trager, Colin Westerbeck, Debra Heimerdinger, Richard Rodriguez, Jim Sheldon, Chris Hansen, Herb Ascherman, Carl Mastandrea, Kay Parent, and Kay O'Laughlin.

Special thanks to Anthony Turney and Anne Garwood of the Names Project for their interest and endorsement.

I am enriched by the people who participated in this project. No amount of words can express what you gave me – from those at the Quilt, who are keeping the memories alive, to those in the Buddy Program and Buddies everywhere, to the Boyces:

Sharon, John, Jeremy, Beamer, Felicia, and Brianna, who made me feel like one of the family, even though it meant watching *Beauty and The Beast* too many times.

Through their collective efforts, the following people have my deepest gratitude. During initial discussions, Bill Ewing made valuable suggestions for the structure of this book and many of these are included in the final product. Special thanks to Natalie Diffloth, who worked on the design and production of the first book dummy. Brian Hotchkiss, senior editor at Bulfinch Press, and his staff were wonderful to work with. Vicki Goldberg, one of the finest writers on photography, contributed her original thoughts to an introduction that enhances this book immeasurably. As writer, editor, and subject in the book, Carol Sutton's contributions were unique and important. Her sensitivity, advice, and moral support earned my deepest appreciation. I am grateful to Germaine Clair for her sense of design and remarkable patience. Given the many parts of this journal, she tirelessly developed these into a final book. I would also like to thank the staff of the Chrysler Museum for their generous efforts.

I am one of the many photographers deeply indebted to Brooks Johnson, Curator of Photography at the Chrysler Museum. I warmly thank him for his vision and unselfish guidance, his dedication to every aspect of this project, a belief in the way I work, and especially for his friendship.

I owe much to Danielle Toth, who, throughout this difficult project brought to it an aesthetic sensibility, and because of this, I am a better photographer.

THE IMAGE OF AIDS

Vicki Goldberg

WHEN IS ENOUGH, I KEPT THINKING, AS IF EVERY TRAGEDY MOUNTING UP WOULD APPEASE SOME SAVAGE GOD.

PAUL MONETTE, *BORROWED TIME: AN AIDS MEMOIR*

AIDS went public in the media in 1981. By March of '82, 285 cases had been logged in 17 American states; a decade later, the World Health Organization (WHO) estimated that by the year 2000, up to 40 million people, half of them women, would be infected with the human immunodeficiency virus (HIV).[1] If it did not take long for the infection to reach epidemic proportions, it took even less time for the media to mishandle the news – not, after all, a time-consuming task – and for the visual imagery to shift with shifting knowledge and awareness.

Images were initially as scarce as hard news in the media, which hesitated to report on AIDS chiefly because it was mistakenly thought to affect gay men alone. More notice was taken when heterosexual hemophiliacs were infected, and then, in 1985, the revelation that Rock Hudson was dying suddenly focused public attention. Media coverage waned and waxed not only because gays are marginalized in this culture (though that is indisputable), but because so much important information is coded in and transmitted through celebrities. As the majority of AIDS cases has moved into the poor, African-American, Latino, and i.v.-drug-using population, the problem threatens to be made half invisible once more.

The early illustrative photographs tended to be either highly technical reports such as photomicrographs or relatively sensationalistic pictures of people near death. As a few drugs were developed that prolonged life; as the media began to understand the magnitude of the problem and to report it somewhat more fully; and as sophisticated critics made themselves heard, at least in the artistic community, the imagery began to change.[2]

But emaciation and disfigurement, especially the lesions of Kaposi's Sarcoma (KS), a cancer that AIDS has removed from the list of rare diseases, remained central to photojournalistic reports on AIDS for a very long time. PWAs (people with AIDS) were commonly shown in hospitals, though they generally live most of their lives at home. AIDS activist groups protested that the epidemic was being portrayed as punishment for sin, a stigma easily inscribed on conditions that can be sexually transmitted.

They had reason to protest. The news all too often opted for cheap drama. When Rock Hudson's illness could no longer be kept secret, some media outlets concentrated on the most devastating pictures of him they could find; these were all the more frightening because his identity depended on his dreamboat good looks and his face was so widely known and envied.

The media's image of AIDS has been even more crucial than usual in shaping public opinion because the epidemic at first clustered in two or three cities and has since been concentrated in the poorest inner-city neighborhoods, so that the majority of

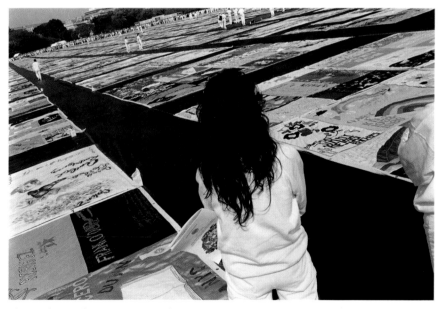

The Quilt, Washington DC, October 1992

Americans knew – know – few PWAs or none at all, but get their information from the press and television. The English critic Simon Watney has even accused the media of being interested in AIDS solely as a portent of death and photojournalists all too willing to oblige with shocking pictures: "[A]s usual, the photojournalist is confirmed in his or her role as the 'courageous' and 'intrepid' explorer of secret and forbidden realms."[3]

Yet abusive as the coverage has often been, there were obstacles, at least in the early years, that made it difficult for photographers to approach the epidemic in an enlightened manner. Before the syndrome was widely recognized or any drugs found that could treat it, many PWAs died rapidly; until 1985 it was not really possible to speak of *living* with AIDS, nor was it easy to photograph someone who looked healthy. Access was extremely limited. Alon Reininger of Contact Press Images started photographing AIDS in 1983, but society so feared and abused PWAs that few would consent to go public.

The press was not eager to publish pictures anyway. Then one of Reininger's photographs, of a man with multiple lesions in a hospital gown and a wheelchair, won the World Press Award for 1986 – and gay activist groups criticized the photographer for victimizing PWAs. Yet it soon became clear that he had actually been one of the first to give AIDS a name and a face.

In terms of images, the most visible diseases have commonly had distinguishing marks – leg braces for polio, bald heads for cancer – and photojournalists were seeking new ones. Someone merely thin and pale had no obvious connection to AIDS. Photographs, especially individual pictures, are grossly inferior instruments of explanation, so photographers frequently try to summarize their points with a kind of visual telegraphy or symbolic short cut. Documentary photographers who tried to improve on the press had few good models to build on. The most famous photojournalistic images of illness have usually been of still-surviving martyrs: Gordon Parks's picture of Flavio, a sick child in a Brazilian favela posed like the dead Christ; W. Eugene Smith's *Tomoko in her Bath,* a mercury–poisoned Pietá; and recurrent

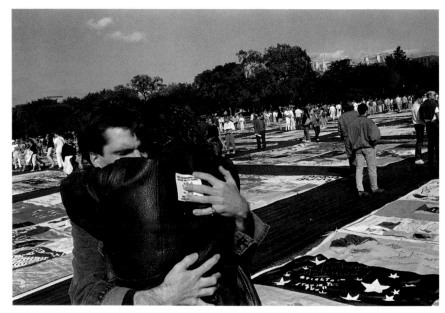

The Quilt, Washington DC, October 1992

images of skeletal adults and children during famines. The one really iconic emblem of illness in this country for years was the child on the March of Dimes poster.

The documentarians tried to be more direct and less symbolic, but when galleries began to show their work in 1988, more cries were raised. Nicholas Nixon's portraits of PWAs in his retrospective at New York's Museum of Modern Art attracted critical praise – and an AIDS activist protest. (In 1991, Nixon's *People with AIDS* [Godine] paired the photographs with extensive interviews that gave them a context and broadened their effect.) Rosalind Solomon's enormous portraits of PWAs at New York University's Grey Art Gallery were also criticized for emphasizing physical deterioration, although only a few of them did so.

Twenty-five years ago, the complaints might not have been voiced. No earlier epidemic had been so politicized, nor had there been such organized attempts to control

the imagery. Though cancer was politicized in law, language, and custom – patients kept their conditions secret or suffered ostracism – the decision to conduct a "war on cancer" in America did not derive much of its force from photographs. But for many people, the Civil Rights, anti-war, and feminist movements, plus mounting unease about the pervasiveness of television in the sixties, sharpened awareness of the power and significance of visual reports in the media.

Then in 1969, a group of gay men stood up to police harassment at the Stonewall bar in New York and discovered that they had a certain degree of clout if they acted as a group. Since then, gay men and lesbians have repeatedly organized attempts to redirect imagery as well as opinion and law. The influence of images, however, is not a science, and the AIDS epidemic has been so overwhelming and bewildering that ideas about its presentation have shifted more than once. For most of the eighties, critics and activists agitated first to increase coverage and then to give images a positive slant, but once pictures of PWAs looking like normal, healthy people began to appear, some worried that if the larger public was less alarmed it would be less likely to support research.

By the second half of the eighties, whether the pressure had worked or wider awareness of the nature of the threat as well as mounting deaths in the art world had raised the consciousness of more image makers, different approaches were tried out. Imagery related to AIDS increased exponentially. Though documentary photographers rarely addressed AIDS before 1985 and artists seldom before 1988, by 1991 it was estimated that AIDS was central to the work of as many as 500 professional artists in the United States,[4] and photographers and artists were looking at the subject from multiple angles and in a variety of forms and styles.

The photographer Gypsy Ray asked her subjects to write their own comments on the mats around their portraits. Brian Weil, who volunteered with PWAs before photographing them and later worked for WHO distributing information on AIDS, spent seven years trying to give visual form to some of the demographic and political complexities of this pandemic with grainy photographs from many countries.[5]

Buddies: Maryellen and Chad

Nancy Burson's 1991 poster, "Visualize This," offered images of a healthy T-cell and an infected one. In 1992, a Boston-based group that called itself Cool Ass Thang organized a traveling show of 50 photographs about living with HIV/AIDS by 50 people who were doing so. Carolyn Jones's 1992 "Living Proof" project, which will eventually be a book, consists of portraits of people living rich, active lives with HIV or AIDS. And there are many, many more.

What cannot be enumerated, much less measured, is the extent to which the arts in general and some aspects of culture have been affected by AIDS. The visual, performing, and literary arts deal directly and extensively with AIDS. An occasional television movie and a rare feature film treat the issue seriously. And the consequences of the epidemic silently filter into the culture at large, where the arts seem preoccupied with death even when AIDS is not mentioned, and representations of male nudity, as well as explicit sexual display of all kinds, increase rapidly in apparent response to the fear of real, live sex.

Sal Lopes's pictures belong to the more recent history of documentary photographs about AIDS. He took his first photographs of the NAMES Project Quilt in June 1988 when it traveled to Boston, where he lives, and his pictures of the Boyce family and the Buddies afterwards. The photographs are not so much about AIDS as about its repercussions – how it has affected the survivors and a wider community who voluntarily choose to involve themselves. Lopes's three photo essays concentrate on compassion and grief, both of which have been stirred to uncommon depths by this grim pandemic.

His interest in the Quilt was a natural corollary of his work at the Vietnam Veterans Memorial, the Wall. Lopes photographed the Wall from the day it was dedicated in 1982 until 1987, and conceived a show (organized by The Chrysler Museum) and a book, *The Wall* (Collins, 1987). By 1988 he had been thinking about AIDS and how to photograph it for some time, looking for a way to keep a certain distance from the overemphasized aspects of the disease itself. Lopes earns his living as a platinum printer, and in '88 was making prints for Robert Mapplethorpe, whose advancing illness also had an impact. When the Quilt came to Boston, he was struck by its similarities to the Wall: both memorials were based on incommensurable loss and both spelled it out in the names.

"People behave at both memorials in very similar ways," Lopes says. "They touch each other in similar ways. They weep. They pray. There is that beautiful silence at both that I love, just a peacefulness. At both they leave messages for the dead. . . . The most amazing thing to me is that they were both designed to memorialize the dead and I think are doing more to heal the living. That's what I'm interested in." Lopes himself says he is not an art photographer but goes for the emotion. His pictures of the Wall, and of the Quilt, are quietly but deeply affecting; he has a sharp intuitive sympathy for the nuances of grief.

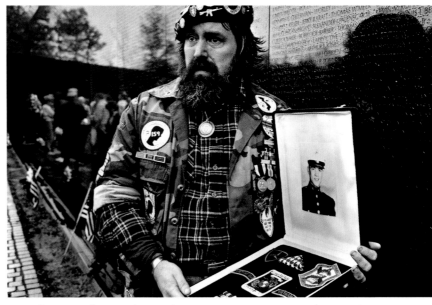

Jim with Portrait of His Brother, at the Vietnam Veterans Memorial, November 1986

War memorials all over this country are engraved with the names of the fallen, but the Wall – how easy it is to identify, even without an adjective – has 58,132 names and stands in the center of the nation's capitol, a natural place of pilgrimage. It draws many people who did not lose anyone in the Vietnam War but know they lost something important. It is an almost uniquely interactive monument. The polished black granite surface gives back reflections of those who come to grieve, and mourners make physical contact with the stone, touching the name of someone they loved, making rubbings, bringing votive offerings as if to an altar.

The names on the Wall (and on the Quilt) stand in for headstones – gravesites without bodies. But the Quilt may be the first commemorative monument of its kind and scope in history. The word *monument* usually signifies stability, immobility, permanence: the Pyramids, the Taj Mahal, the Lincoln Memorial. The Quilt, however, is fragile, elastic, and portable. A piece of fabric may last a very long while – the Bayeux tapestry,

which chronicled the Battle of Hastings in the eleventh century, is still extant – but stone is expected to last longer, and memorials are not made from textiles. Rarer still, this monument moves, traveling in ever larger truck convoys from city to city, coming to the people rather than magisterially awaiting their attendance. It resembles a traveling passion play more closely than a cenotaph to fallen soldiers.

If the Quilt's location changes, its shape and scope change yet more often and more radically. This may be the most mutable monument ever designed, its unfixed nature an essential part of its concept. The mourners who seek solace from it are invited to inscribe names, notes, poems, to leave their marks and change it. The Quilt is both a memorial to the dead and a virtual shrine to graffiti. An ongoing epitaph. A tombstone in process. Not an afterword but a commemorative address spoken even as the dying proceeds – and like grief itself, it grows as things get worse. The sorrow is very fresh around this monument, and Lopes's camera picks up that immediacy, just as it did at the Wall, where sorrow was fresh enough.

Lopes records the exuberance of amateur, folk, and cartoon art, collage, embroidery, and fancy designs on this soft monument, and the messages that increase with the mourners. A man wearing a cape full of photographs of the dead. Shadows falling across the Quilt as reflections fall across the Wall. A hand covering a name. And people touching one another, over and over, people holding hands, holding on, hugging – the ultimate language of grief, when ordinary language fails.

The photographer says he wants everyone he photographs to know they're being photographed. He uses only short lenses and photographs as close to people as he possibly can, and if they are not so happy with that, he does not necessarily walk away. "There is a predatory nature to what we do as photographers," he says, giving voice to that faint uneasiness that underlies even the most sympathetic approach in documentary photography. But his results speak convincingly of intimacy and trust rather than confrontation.

The two other essays in this book, which focus on people both living with and dying of AIDS – some of the PWAs in the Buddies program died before he took many pictures – chronicle the extraordinary commitment of some who were not drafted but signed up for involvement. Lopes is particularly interested in human resiliency, the inexplicable and unexpected reserves of spirit in people with no special claim on glory. It must have been clear to those he wanted to photograph that he did not mean to concentrate on despair.

Volunteers for the Buddy Program in Boston go through intensive, emotionally exhausting training for two long weekends and are assigned to a PWA to be there for him or her through good times and bad. Lopes took the training himself to understand the process

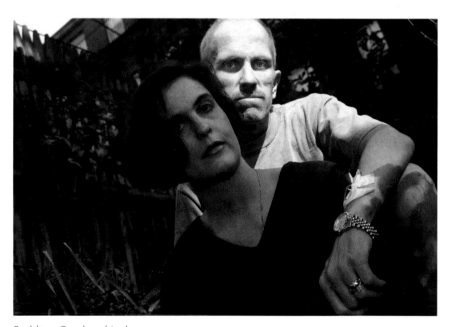

Buddies: Carol and Jack

better. His pictures have some narrative elements, like the sequence of a man named Larry going home from the hospital for his birthday, but mostly they are portraits. Serial portraits, sometimes – people conversing, or just sitting for the camera for short periods, or people together over longer intervals – but mainly, and simply, dual portraits.

Historically, such portraits indicate attachment, a bond of love or other tight connection: husbands and wives, mothers and children, lovers. The couples in Lopes's photographs – and they are couples, some of whom will have relatively extended relationships – are together because one of them is sorely threatened with disease and the other may not be and is therefore donating the extra energy and empathy of a healthy life to someone with a shorter supply.

Portraits of people linked in this manner and for this reason are not common in art or photography. In photo essays on medicine, such as W. Eugene Smith's "Country Doctor" and "Nurse Midwife," individual pictures of doctors or nurses tending patients might qualify, and occasional portraits like Cartier-Bresson's of the elderly Colette and her companion turn up. But not only are these not plentiful enough to be called a genre, but they are explicitly about relationships of dominance or authority – Colette's companion is not even named – or about a professional performing a service.

Lopes's pictures survey another, very complex, and at least on the surface more nearly equal situation. The tradition of dual portraits has no slot for this particular relationship. One member of the couples in his pictures is under a sentence, but a sentence he or she may serve only in the future. The other elects the companionship, asking no rewards but what may come of it. Portraits of two people in a voluntary alliance (such as marriage) automatically invite speculation about the qualities of the individuals and their interactions, but knowledge of why the people in this book are joined prompt a viewer to question their likenesses for different kinds of clues: what are their motives? what is this doing to/for both of them? could I do this myself?

The questions are especially pointed because it is not always so easy to tell at first glance who is who – which in itself makes a point about living with AIDS, and which was wholly intentional on the photographer's part. And when the one who is probably dying faster than the other is singled out, it is still, often, hard to tell from the expressions on both faces whether their thoughts are different. Perhaps one serious look is much like another. Perhaps both partners are more often than not thinking about the same thing: why they are together, and why they are being photographed.

At all events, the content of the pictures is packed in layers. First, the features: who are these people and what are they like? Then AIDS, evident or not. Then the relationship – and here is where these portraits, with their texts, add another footnote to the visual literature about AIDS. They are about the larger community's compassion and willing involvement, an oblique reminder that AIDS ultimately affects everyone.

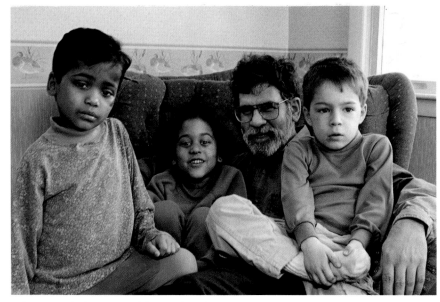

Sal Lopes with the Boyce children (photo by Jeremy Boyce)

The Boyce family photographs proceed in depth along the same lines. This couple, who could not have children, adopted four within thirteen months, ranging in age from an infant to a fifteen year old – a stunning change in circumstances that would rank high on any stress test. The Boyces compounded this by first adopting a baby with the HIV antibodies in 1988, when infant AIDS was not well understood, and later adopting one child with full-blown AIDS, her sister, who had the HIV antibodies, and their half-brother. The two infants who had been exposed to HIV might (or might not) outgrow the condition. (In fact they did.) At the time Lopes photographed the family, Brianna, the child with AIDS, had already outlived the medical prognosis.

There is ample evidence in the photographs that Brianna is seriously ill but none that she is ravaged and no signs of despair anywhere. On the visual evidence alone, this is a happy family, far happier than many with lesser battles to fight. Lopes's overview of the family and the child's illness is a relatively traditional black-and-white photo essay of a family – though the only real "activity" is tending Brianna – of a kind that American magazines no longer make much space for. It pivots about the girl's remarkable beauty and the fact that although she is a very serious child she has apparently received such strong support that she is neither afraid nor despondent.

It would seem that every single time the adults are with the children one of the parents is holding at least one of the youngsters. In all three of Lopes's essays people touch each other a lot – no doubt in more ways than one. "When I hugged you," a survivor writes, "you whispered, 'Thanks for touching me,' and that's when I really lost it." For certain deep human emotions, physical contact is the most complete expression – and besides, it is an expression the camera can register unequivocally.

The extent and the ramifications of AIDS – the threat it poses to the American health care system, for example, or to the economies of developing countries everywhere – cannot be compassed by photography. Photographers like Sal Lopes can only hope to broaden the horizon a bit, to narrow the gap between us and them, to suggest how ordinary, how truly ordinary, both heroism and tragedy have become.

New York, March 1993

1. 1982: Randy Shilts, *And the Band Played On* (New York: St. Martin's Press, 1987), p 131. 1992: Hiroshi Nakajima, guest Editorial, *The Earth Times* IV (December 1, 1992): p. 1.

2. Among other critics of the media, see Simon Watney, *Policing Desire: Pornography, AIDS, and the Media,* 2nd edition (Minneapolis: University of Minnesota Press, n.d , ©1987, 1989); Douglas Crimp, "Mourning and Militancy," *October* 51 (Winter 1989): pp. 3-18, and other articles in that issue; Susan Sontag, *AIDS and Its Metaphors* (New York: Farrar, Straus and Giroux, 1989).

3. Simon Watney, "Photography and AIDS," in Carol Squiers, ed., *The Critical Image* (Seattle: Bay Press, 1990), p. 182.

4. "Art about AIDS: Two Voices – Multiple Contexts," in *From Media to Metaphor: Art about AIDS,* Robert Atkins and Thomas W. Sokolowski, guest curators, traveling exhibition organized by Independent Curators Inc., New York, 1992, p. 18. My thanks to Mr. Atkins and Mr. Sokolowski, as well as to Phil Block, Verna Curtis, Allen Frame, and Bill Hunt for their helpful advice. The art and photography worlds, incidentally, have responded generously to the crisis, organizing shows, benefits, auctions, and an annual Day without Art to keep awareness high.

5. See Brian Weil, *Every 17 Seconds: A Global Perspective on the AIDS Crisis* (New York: Aperture, 1992).

THE QUILT

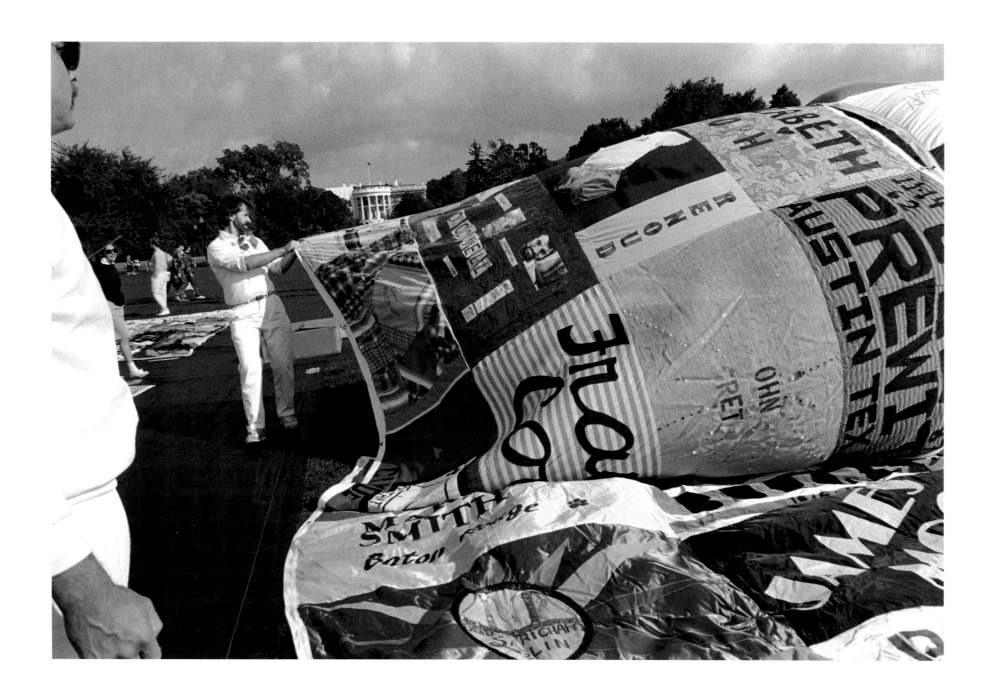

This is perhaps the most appropriate legacy one could conceive of for the ever-expanding population whose lives have ended prematurely because of AIDS.

The Quilt is unlike other memorials. It is a work in progress. So it is appropriate in that as the number of deaths increases, the memorial grows as well.

At the same time, in trying to keep up with the number of HIV-related deaths, the memorial has, in effect, outgrown itself. Now its vast dimensions dictate that it will likely not be shown again in its entirety. Those whose lives and deaths are immortalized in the Quilt probably cannot be represented again as a whole.

But the Quilt is more than a growing testament to those who are no longer here in the physical sense. It is also a powerful vehicle for AIDS education because it personalizes the often sterile statistics. Whether the entire Quilt is exhibited, or a single panel is displayed in a school classroom, the same message is conveyed. There are names and faces behind each panel; individuals who lived and loved and are now gone, and loved ones left behind who grieved at their deaths and grieve still. The Quilt stimulates discussion and helps educate people by transcending the fear and stigma attached to AIDS. It simultaneously humanizes and personalizes an often faceless disease; a disease that affects "other people."

It is also a powerful catalyst for action – a resounding call for policymakers to acknowledge the global context of AIDS and the role that the United States must take in finding a cure. We have the resources; we have the knowledge and expertise. What we still await is the will. No one should have to become a statistic to such a horrible disease, and no one should have to witness such a thing.

The Quilt was conceived of by Cleve Jones, a man who, like so many in San Francisco in the mid 1980s, began losing one friend after another to AIDS. In November of 1985, an idea emerged for a way to remember them, at the annual candlelight march honoring two San Francisco politicians murdered in 1978. In the midst of planning the march, Cleve learned that 1,000 San Franciscans had died of AIDS. He asked those joining in the march to write down the names of friends and loved ones who were among the dead. In the aura of the candlelight, Cleve and others stood on ladders and taped the names of those people to the walls of the San Francisco Federal Building.

Stepping down from the ladder, Cleve was affected deeply by the image that was emerging. The squares bearing the names resembled a patchwork quilt. At that moment, the idea was born. Cleve conceptualized the NAMES Project AIDS Memorial Quilt, and early in 1987, he created the first panel in memory of a friend. Later that year, the NAMES Project Foundation was organized.

Could anyone have predicted the extent of the impact that this concept would have on the consciousness of the American people and the world? Response was immediate and immense. Panels began arriving daily; people were generous in offering their talents and services to those who wanted to create panels. The size of the Quilt grew proportionate to awareness of the project.

The Quilt was displayed for the first time in 1987, on the Capitol Mall in Washington DC. It spanned an area larger than two football fields, and nearly all of the 2,000 panels represented gay men, most of those American. It was estimated that half a million people visited the Quilt that weekend, a response that led to a four-month, 20-city

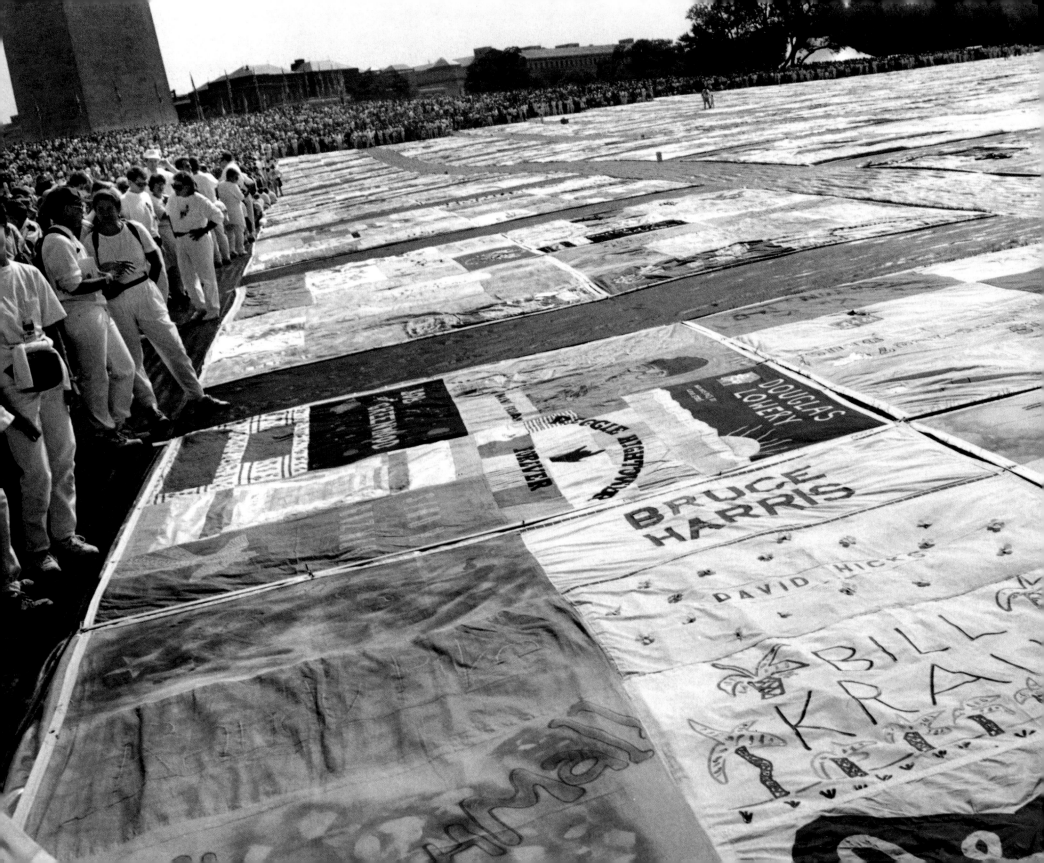

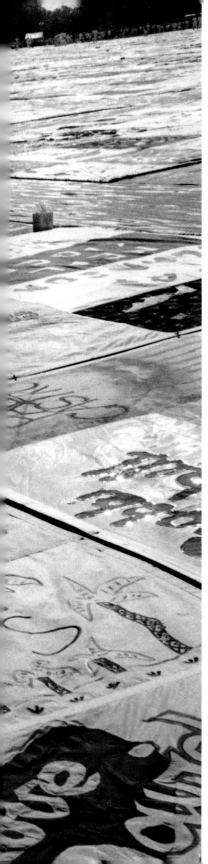

national tour in 1988. By the end of the tour, the Quilt had more than tripled in size, to over 6,000 panels.

Later that year it returned to Washington DC. This time, hundreds of celebrities, politicians, family members, partners, and friends read aloud the names of people represented there – an intensely emotional ritual that continues to this day. A long line forms, and one by one people speak the names of some they never knew, and several they loved and lost. A message from lover to lover, parent to child, wife to husband, nurse to children on an AIDS ward. A considerable number of losses are recent, and the pain on the faces and in the voices is palpable.

As people descend the podium, having offered a tribute to those they love, their grief is renewed, raw. An Emotional Support Team, dressed all in white, is waiting to offer whatever is needed: a supportive arm around the shoulders, words of empathy and understanding, or merely silent presence.

The Quilt has traveled to locations as diverse as a maximum security prison in California to a museum in Russia. It has been viewed by people in public schools, hospitals, churches and synagogues, theaters, shopping malls, airports, and convention halls.

Today, the Quilt speaks with a power and eloquence that words would be incapable of, about the consequences of this virus. It now represents tens of thousands of men, women, and children from countries and cultures around the world – people inexorably bound by this disease; joined by a common denominator, a common thread, a common enemy. It offers an opportunity to see, in a deeply intimate way, their lives as experienced and remembered by those closest to them. The panels are as individual as the people they represent. Three-dimensional portraits or composites of photographs, stuffed animals, Mardi Gras masks, a favorite jacket or hat. Even a poignant poem or statement: "They gave me a medal for killing two men and a discharge for loving one" (page 33). This is remembrance at its most personal.

The growth in the number of three-by-six-foot panels, from a solitary panel in 1987 to over 25,000 by the end of 1993, parallels the progression of the devastation. Twenty-five thousand panels in only six years represents a new panel about every two hours. This is a horrifying statistic.

The Quilt provides a living, almost breathing place to mourn those losses. More important, however, this memorial serves as a celebration of individuals who touched us and will remain a part of us forever. It is a magnet to those whose lives have been affected by AIDS. Loved ones make pilgrimages to pay tribute. In caravans of gigantic trucks filled with fabric, the Quilt moves from city to city, and the people come. Again and again, they come, to mourn, to remember, and to celebrate.

The formation of a panel begins with friends, family, or partners who want to create a permanent visual representation of their love. Help is available with sewing, cutting, folding, boxing, stapling, hammering, or whatever else is needed.

Panels are then sent to the NAMES Project Foundation, logged, and sorted by geographic region. Eight from the same region are assembled and sewn together to form a 12-foot section of the Quilt. Then sections are numbered to make it possible to locate a particular panel, and the panel maker and numerical information are stored in a database.

The October 1992 display was composed of about 20,000 panels totaling 12.5 football fields with walkways. It weighed 30.7 tons. The 12-by-12-foot sections began the journey from San Francisco to Washington DC in eight 48-foot trailer trucks loaded with 700 boxes of panels. From there, the precious cargo was taken to Oakland to be transported by train to Washington DC.

The statistics are staggering. In mid 1987, when the NAMES Project was founded, about 20,000 people in the United States and many tens of thousands worldwide had died of AIDS. Only five years later, approximately 150,000 Americans and a million people worldwide were dead. An estimated 11 million people currently are infected with HIV. The World Health Organization predicts that by the year 2000, that number will increase to 30-40 million, 90 percent of those in developing countries. No end is in sight.

And yet, each time the Quilt travels from the workshop shelves to another location, it is remarkable to note the seeming contradiction that exists.

The initial impact is overwhelming. One can't help but be devastated by such a massive visual representation of this pandemic. Language isn't sufficiently rich to describe the sight of more than twenty thousand grave-sized panels covering such an immense expanse of land. And yet, it is somehow difficult not to be affected by the sheer gentle splendor of individual panels and their cumulative effect. It is, at once, both horrifying and remarkable in its beauty. The love and tears woven into each panel is evident, telling us that we must remember more than just the deaths documented there; we must also remember the lives. What other memorial has melded these so effectively?

The Quilt: it is more than a symbol of immense loss. It is a symbol of hope — a vital and powerful reminder that we are a *world* living with AIDS, not just those with HIV infection. *Each one of us.* In the words of the International Display Coordination Team of the NAMES Project, this is a monument built of love, tears, joy, rage, compassion, and hope. It is a monument to those we have loved and lost, and whose lives we gather to remember and celebrate. It is a monument that cannot be ignored.

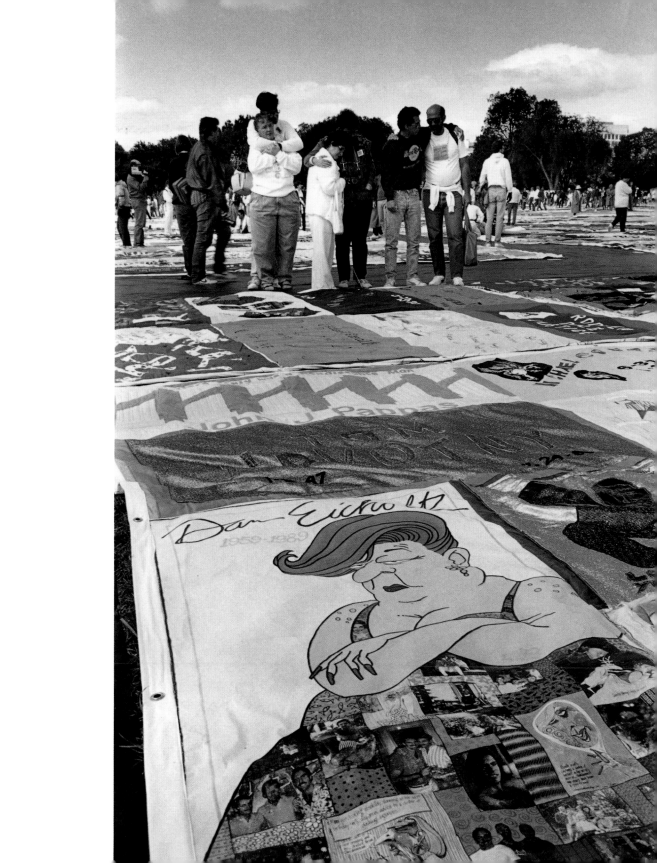

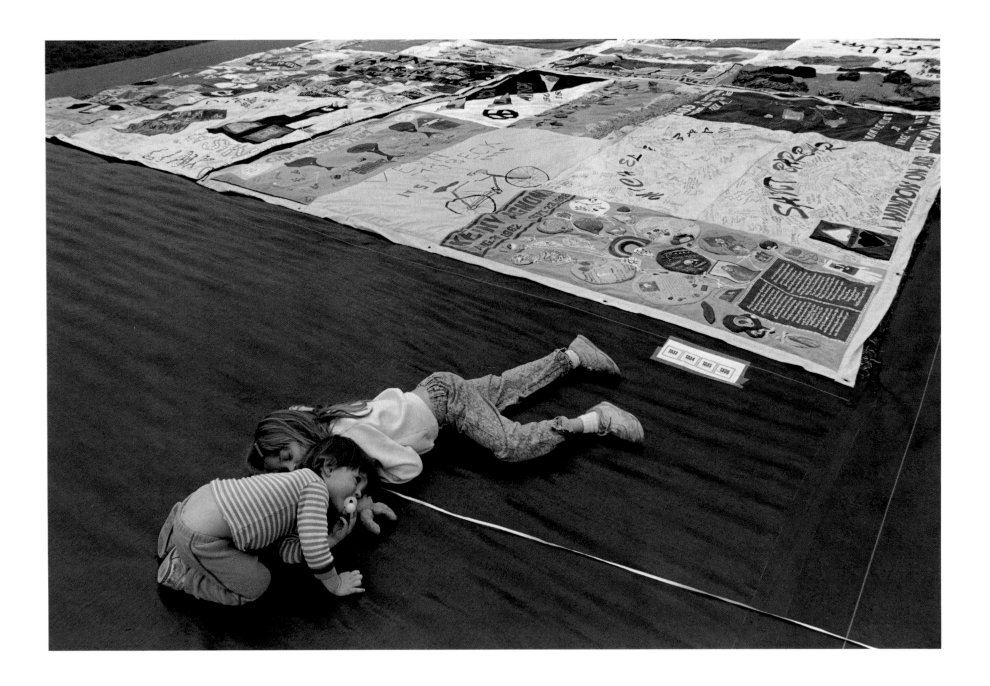

18

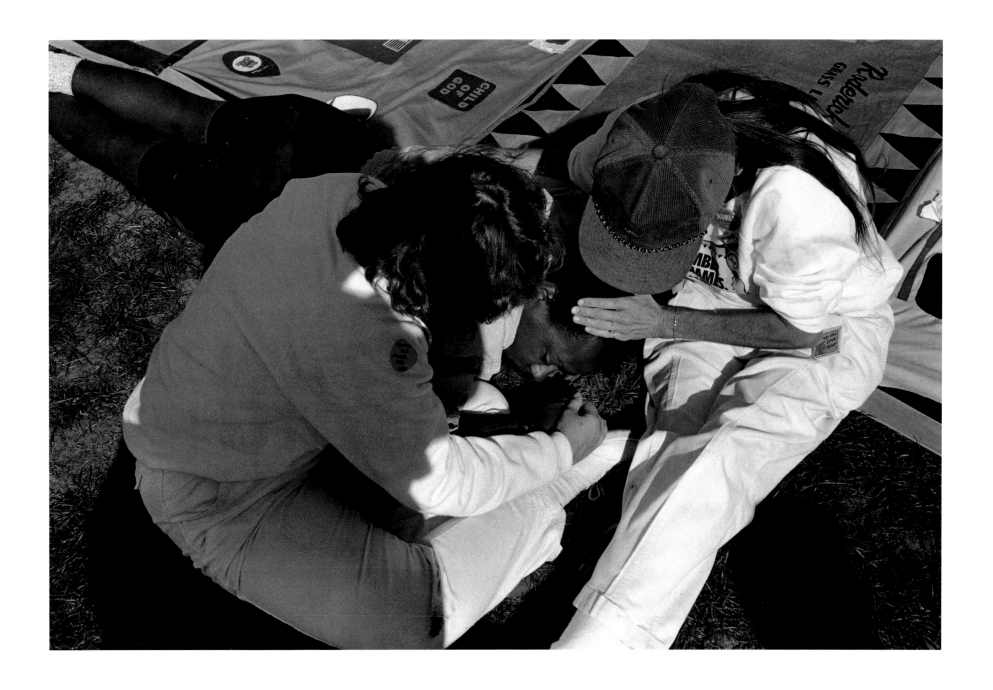

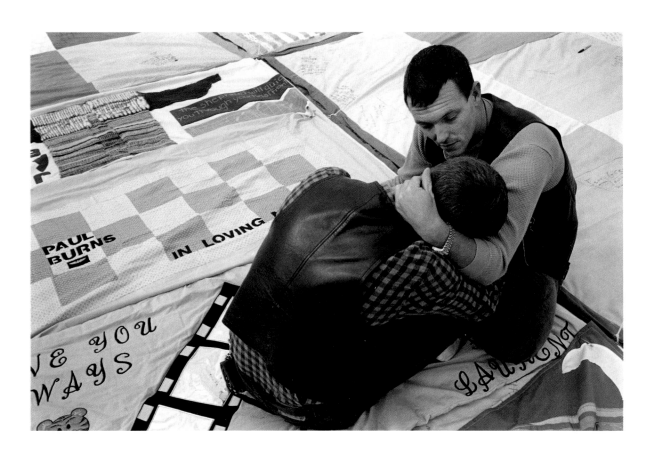

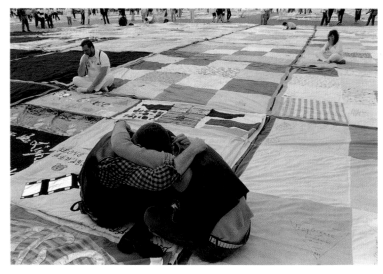

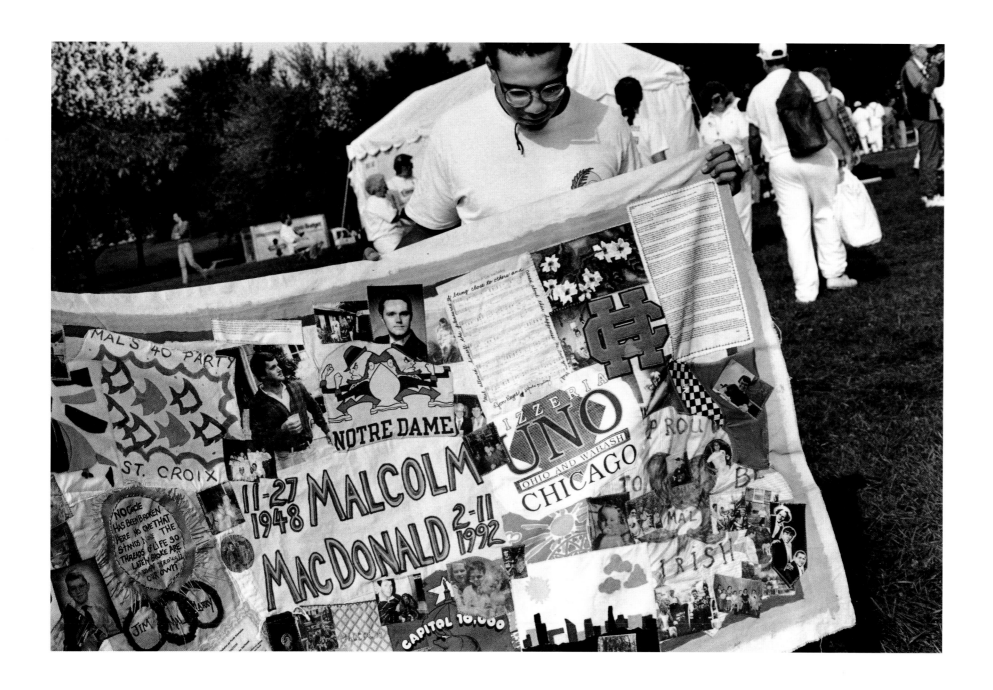

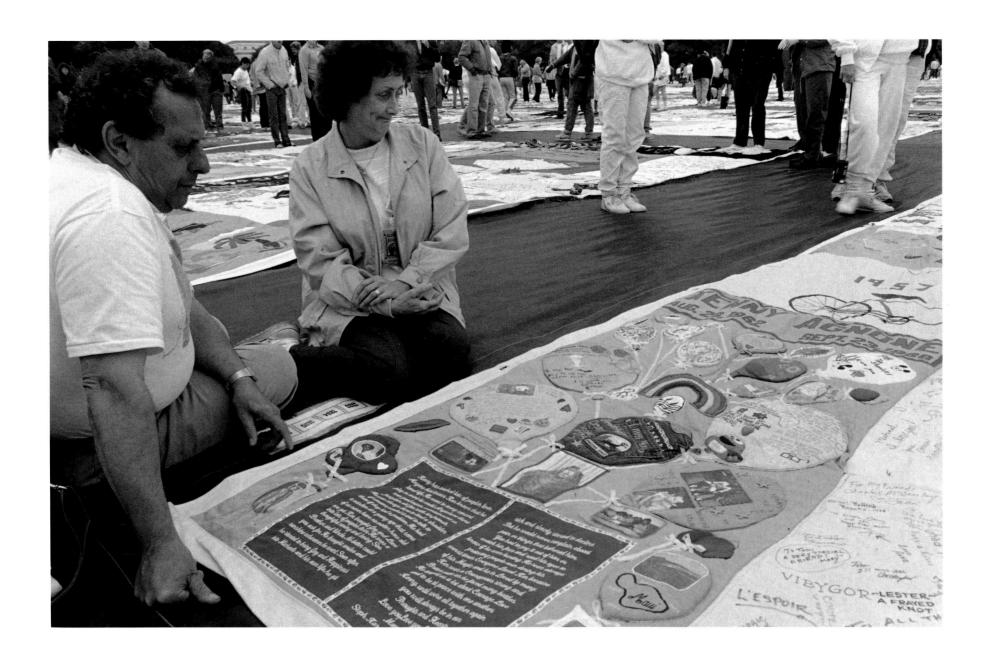

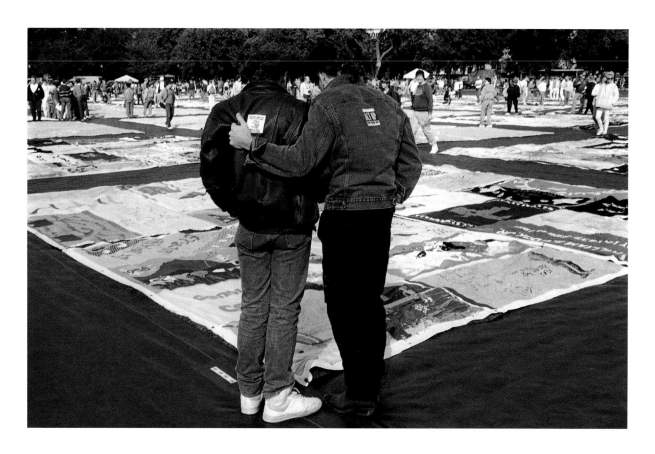

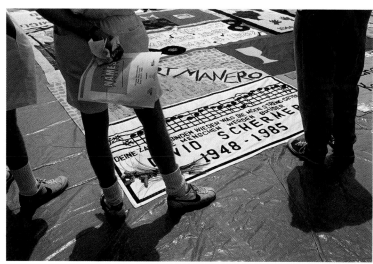

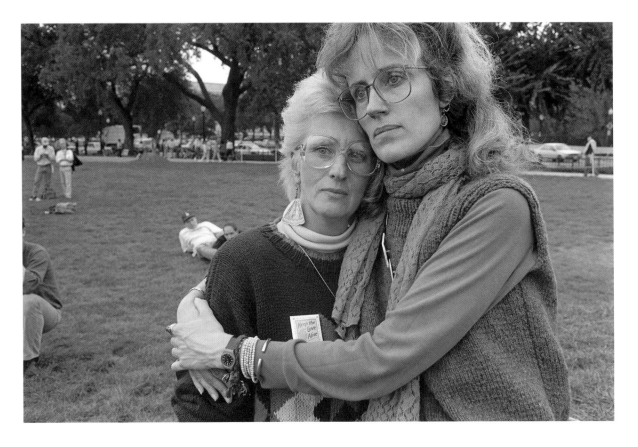

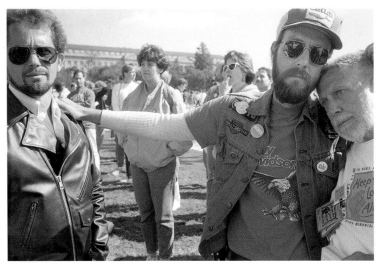

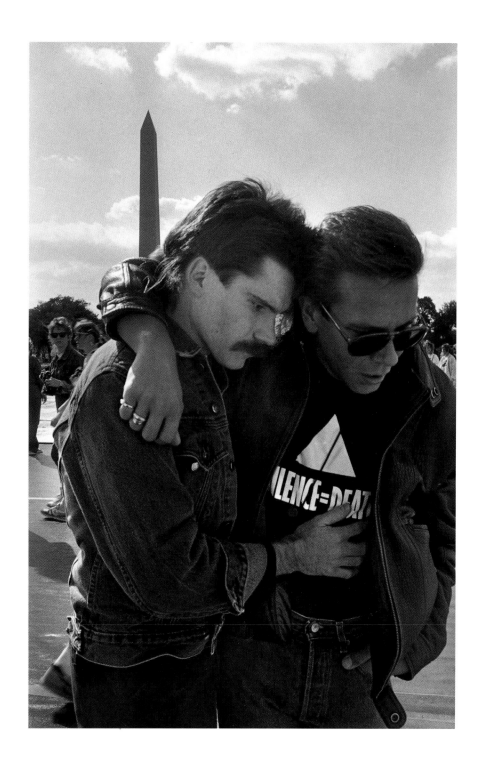

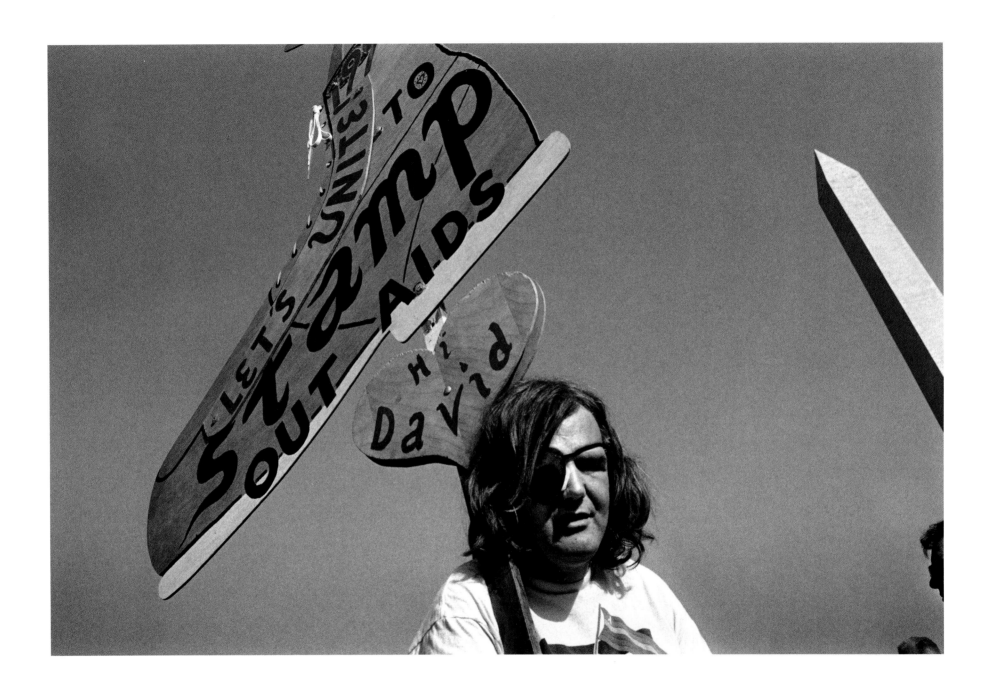

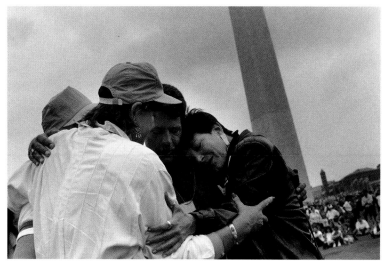

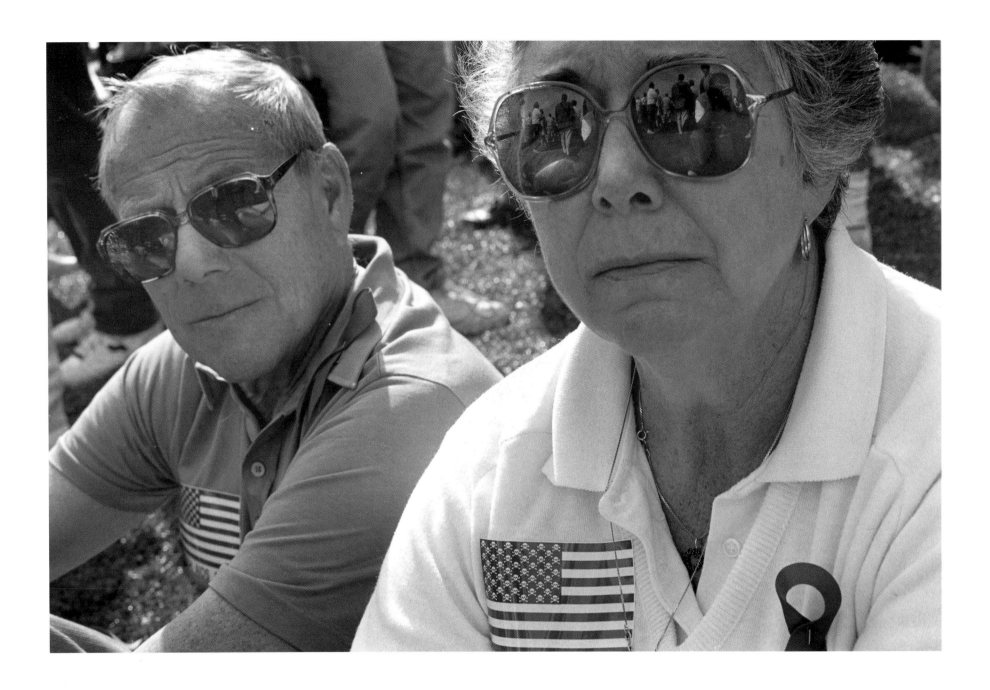

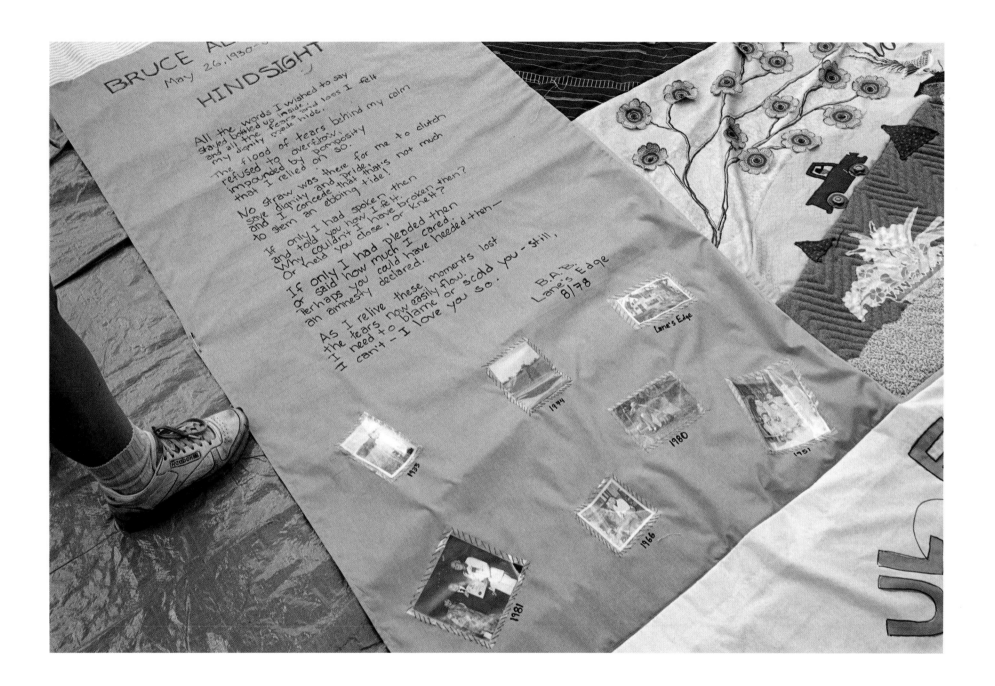

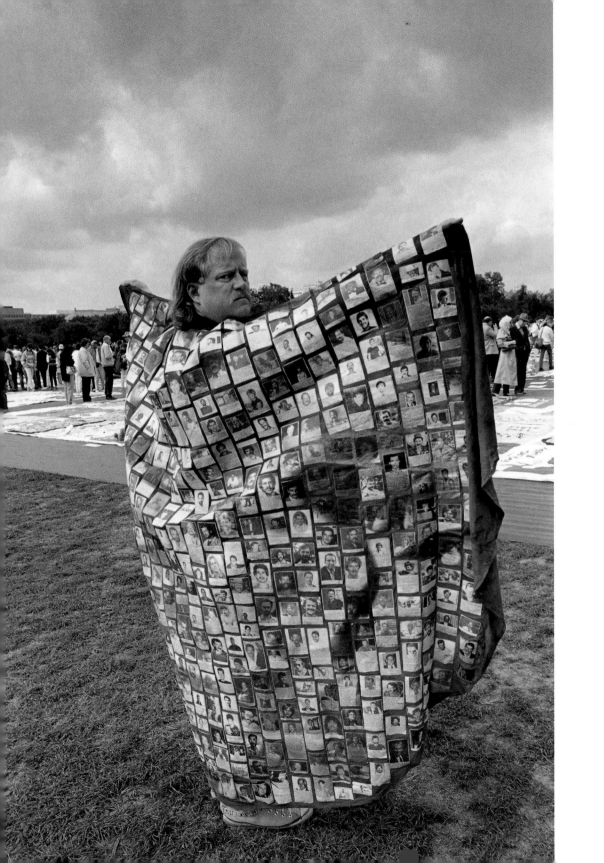

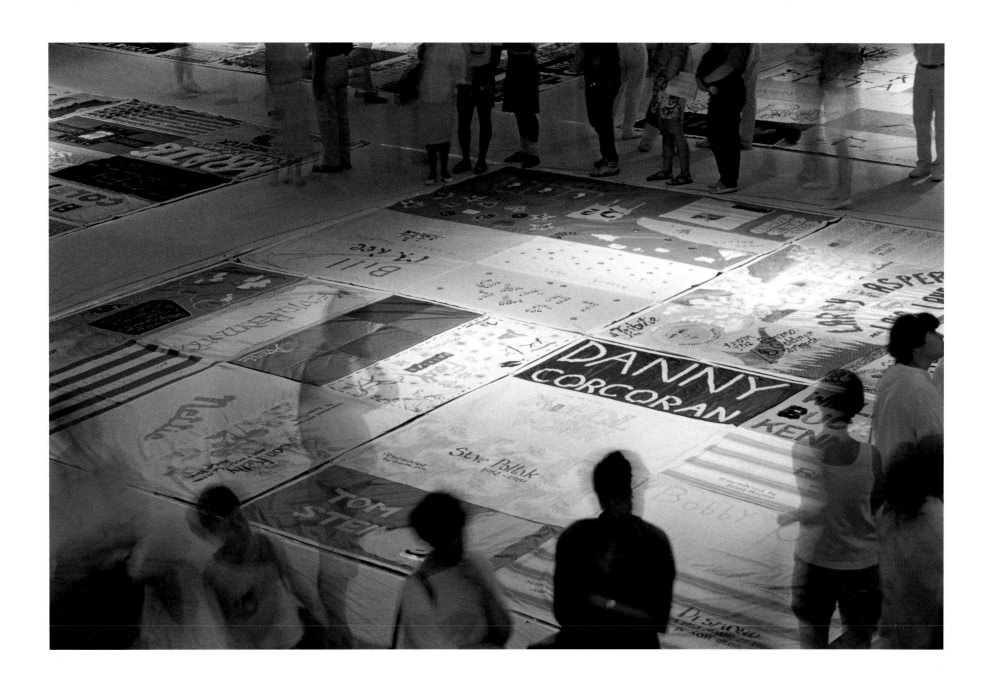

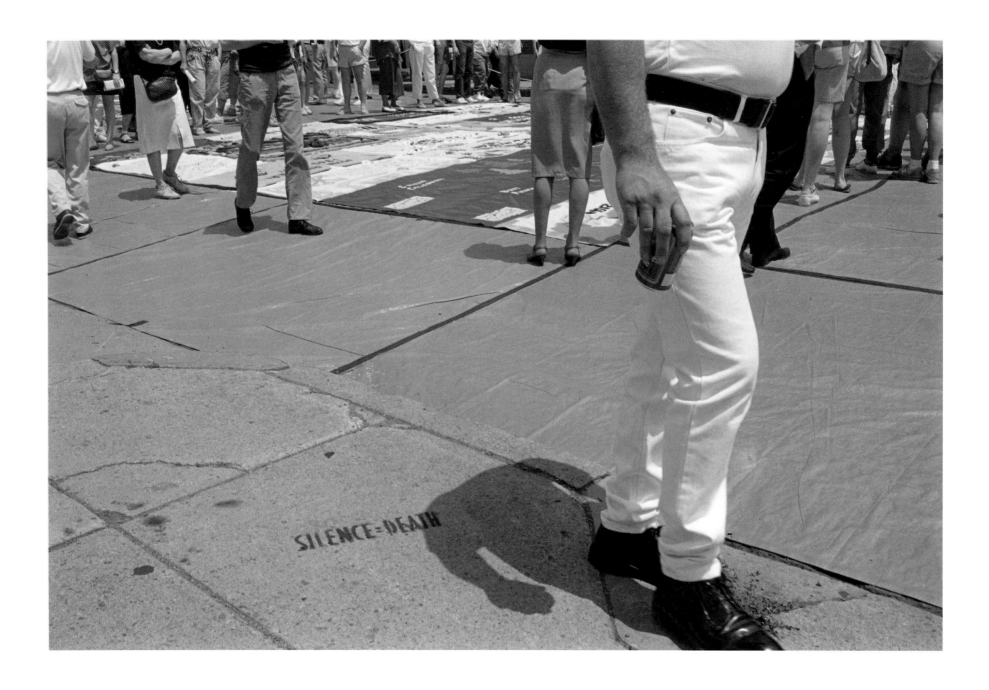

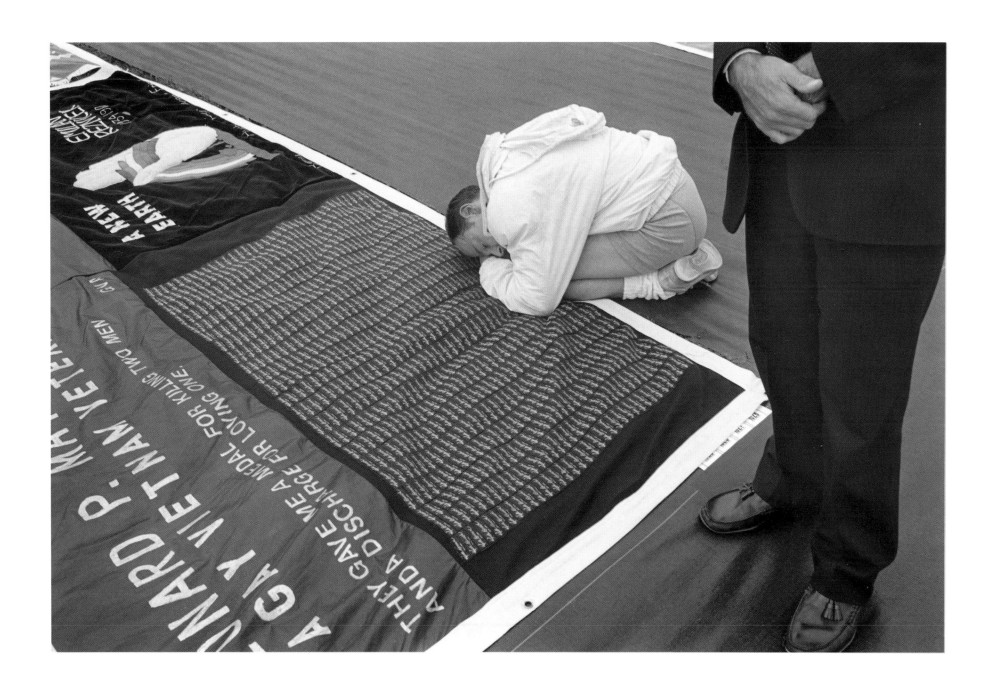

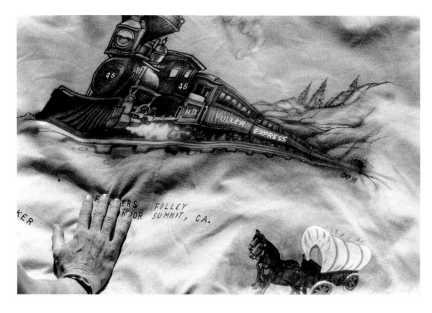

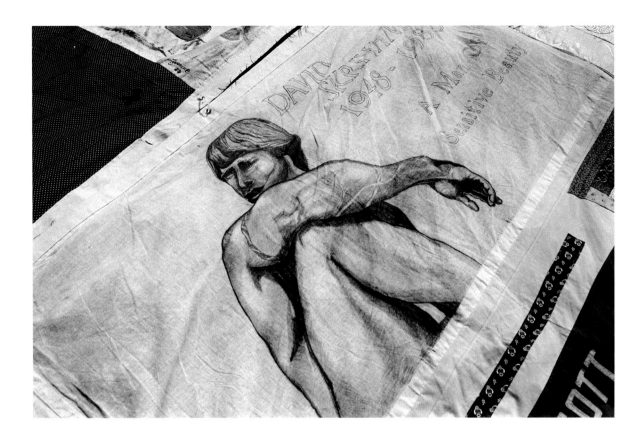

Tough talk about times gone by.
Tough talk always.
I bet you were born with a swagger and
 six-guns blazing.
And your soul took its leave the same way,
A proud fighter – so gracefully amazing.

You were a rastaman.
A dread-locked desperado, bopping to
 a reggae beat.
Cherishing memories of your sawed-off shotgun,
And life on the street.
But you were the victim of a slimy stick-up.
AIDS robbed you blind.

Your dreads went first, then your sight,
and finally it took your mind.

Buddy, as my thoughts of you turn sentimental,
All that remains is what's essential.
You demanded things be done just so –
A great manipulator, specializing in stalling.
Even as your memory started to go,
I found your chutzpah galling.
Your peanut butter had to be smooth,
You pleaded for grape-nut ice cream,
 sweet and crunchy,
You were unyieldingly picky about food,
We trekked to Pizza Huts, for your favorite munchy!

Sharing wild stories and wicked fantasies,
Your talk took me to places I'd never been,
From the luscious West Indies,
To the bad-boy ruled streets of Brooklyn.
You were a great talker, –
And I loved to listen.
One day you said something there was
 no denying,
You said, "Boy, it looks like I'm dying!"
"Looks that way," I replied.

In the "end stage," we slowly said goodbye.
Remember our last words of affection?
As you lay confined in your hospital bed,
"I love you too," you said,
Thanks for that unplanned peace of perfection!

The end of your life,
Was much like the rest,
But you also came to know,
Life's more peaceful aspects.

In a final vigil, friends and family gathered 'round,
Some who previously were not to be found.
When's it gonna be?
When's he going to fly?
All waiting, anticipating the big event,
Finally you dropped at my feet, a bird
 fallen out of the sky.

"Amazing Grace" made a bitter-sweet sound,
As they lowered you into the ground.
Now we're both making a new start,
You, freshly birthed into the next world,
And me left here with ambivalence, fury,
 and a broken heart.

 Journal entry by an anonymous Buddy, 1992

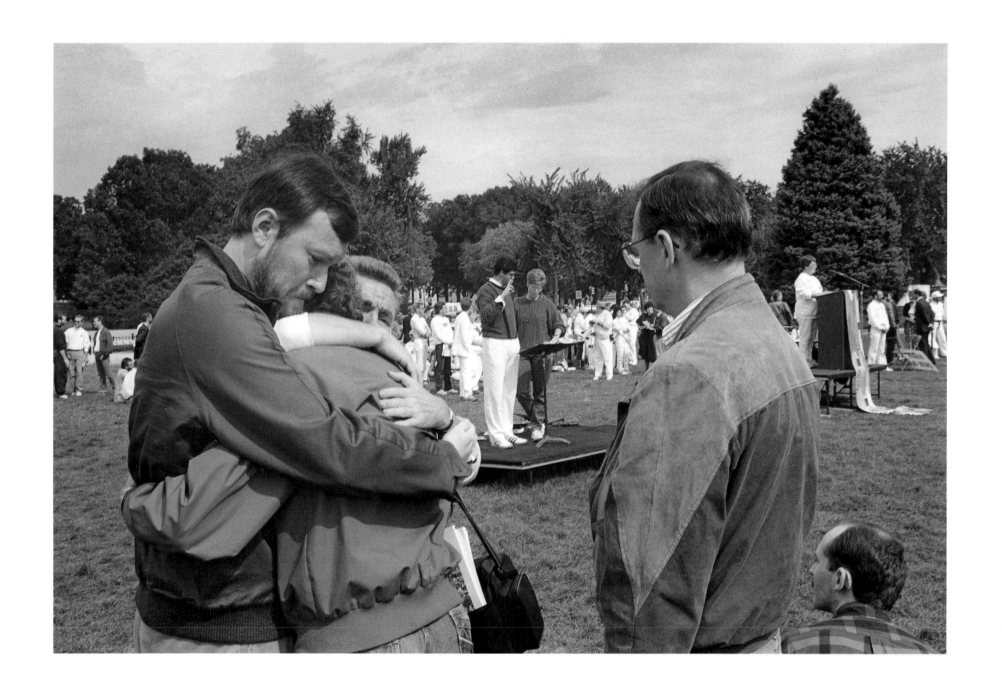

37

TIDEWATER COMMUNITY COLLEGE

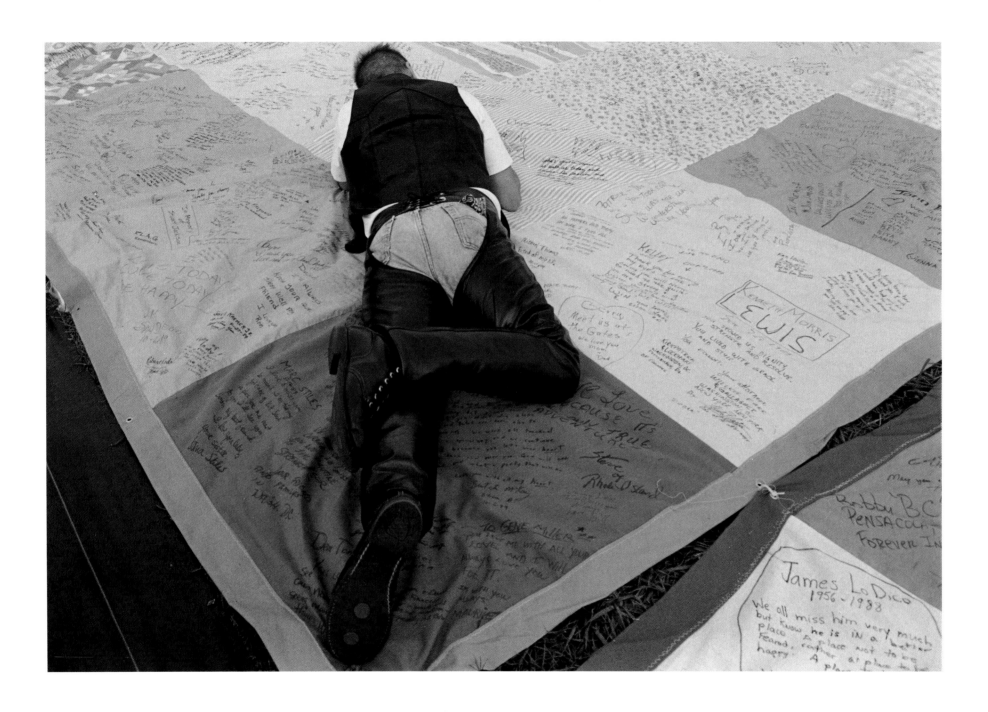

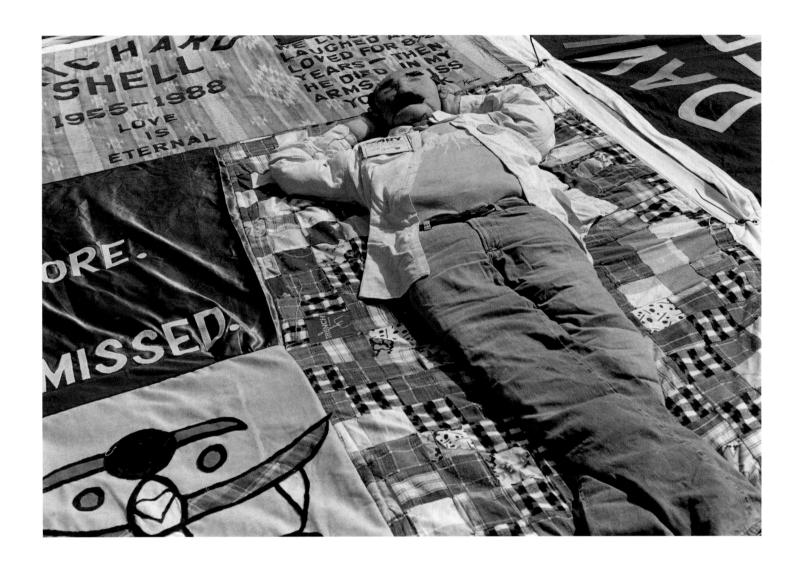

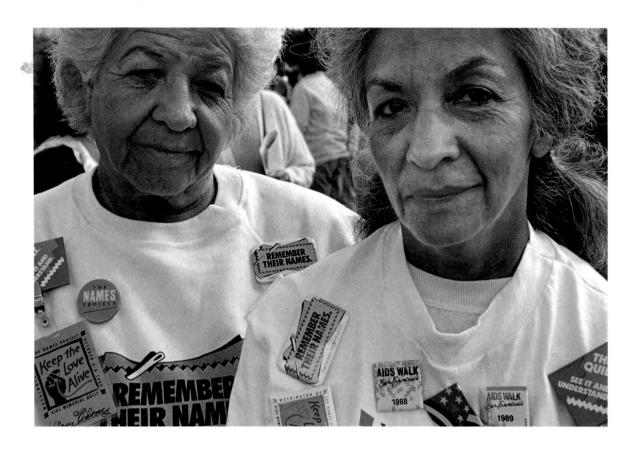

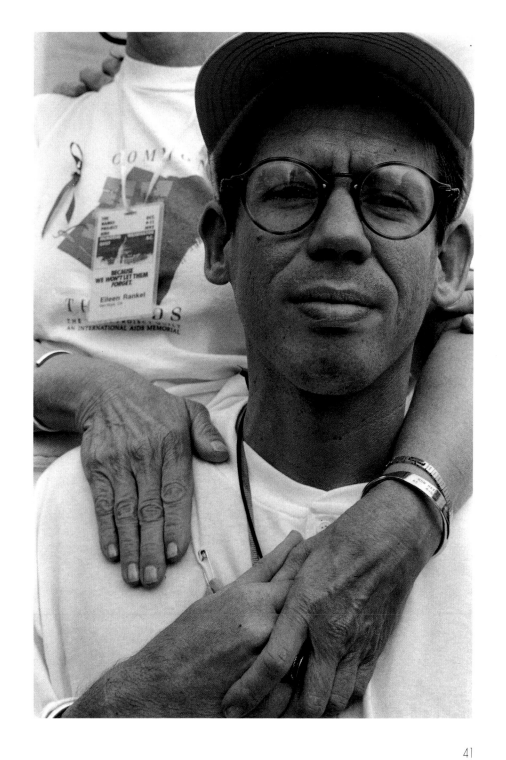

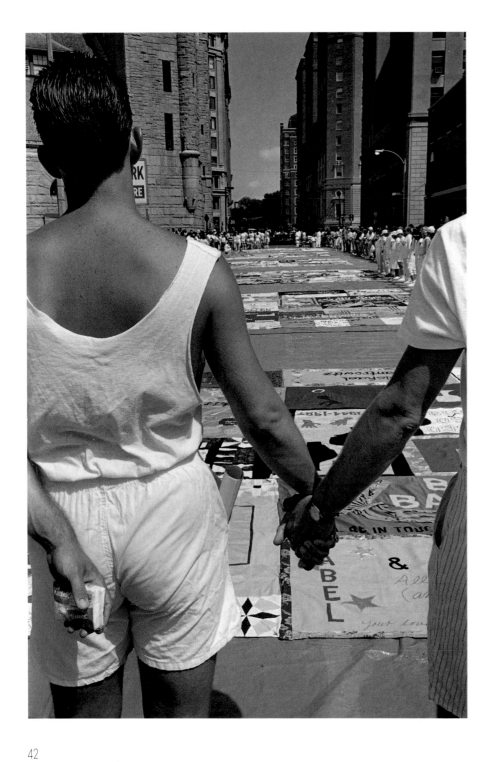

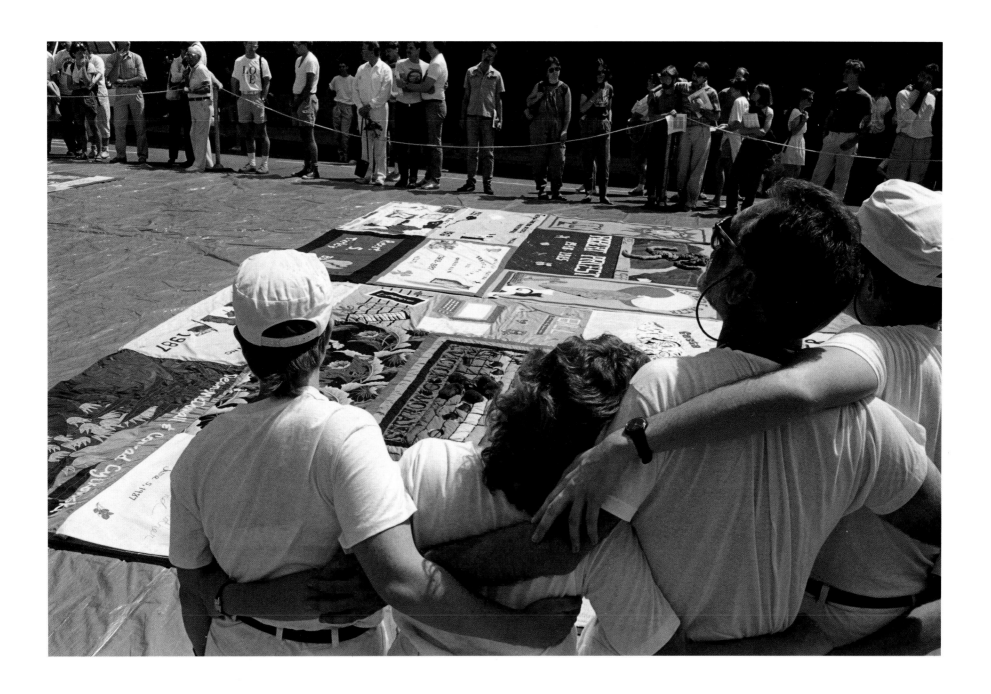

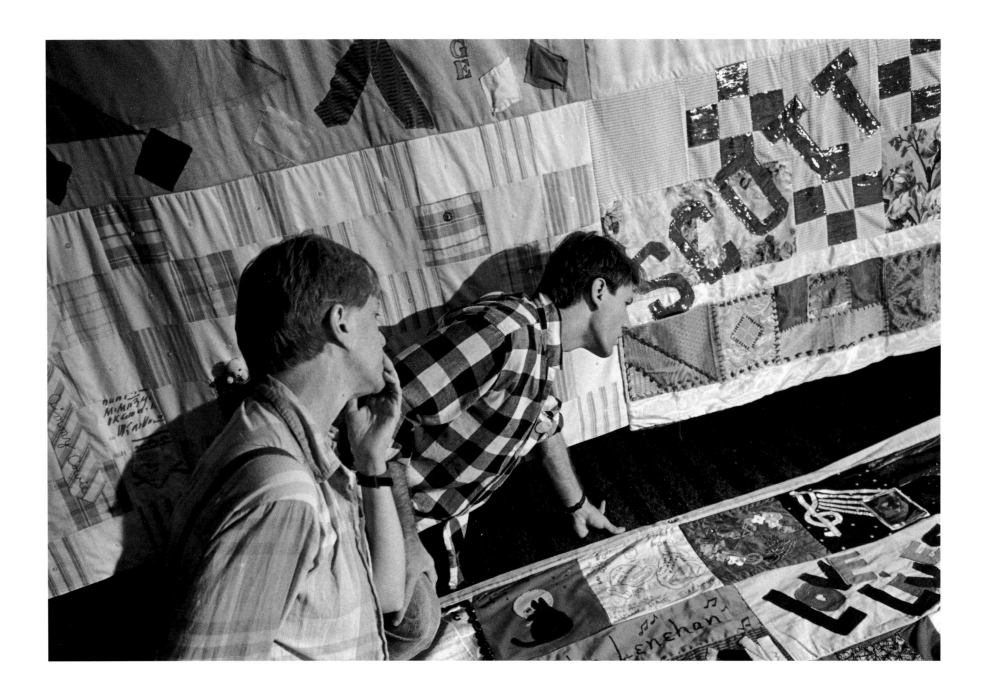

You got a day pass from the hospital for the Walk For Life, and I immediately picked you out from a crowd of 10,000. I hadn't seen you out of doors in months. You wore your death like a yellow slicker.

What can it feel like to walk around healthy people so branded? How does it feel to have your death so visible? Is it like a Halloween costume you can't get out of? You looked so small and jaundiced. I held you and we cried. I cried for loving you and I cried because I was starting to say goodbye.

We walked through the crowd. Even then, so weak and yellow you prima donna-ed as of old, getting different looks than before. You wore your yellow the way you used to strut your butt down Commercial Street. Your cruising stride had become a swagger of mortality.

Others looked and saw their own death. They saw you parading your yellow leather; and some shrank back, and some whispered, and some shuddered. And some came up crying to hold you, and be held by you. And those I liked because you weren't a thing to them . . . you were Danny. And it hurt to hold you and it hurt to look at you but we did. To feel you and have you feel us back. When I hugged you, you whispered, "Thanks for touching me," and that's when I really lost it.

You've made me more fearless with my heart. I watched you squeeze every bit out of life, down to the last bloody second.

The last time in the hospital – when they pulled the tube out of you and we all thought you were going to die right then? You sat up and the first thing you said was, *"Don't touch the hair!"* Then you asked for a make-up mirror.

Then later when your lungs started filling with water, and they began putting morphine in your i.v. – when the doctors who couldn't tell us what you were dying of came to help you die slowly – when you started drowning inside, we all sat around you, and sang and told stories and held you . . . you held on tight to every last bit. You stayed alive so long because we wrapped you in memories and songs and foot-rubs. We wrapped you in so much love you didn't want to go.

After a while that gurgling changed.
It changed into a lion cub snoring.
And then that lion cub snoring,
changed into a lion cub purring.
And. Then. You. Left.
Still and pale in the bed, a yellow rose lying down.

I miss you and I want you to know something – I don't know where I'll be in 30 years, or 20 . . . or six months from now . . .

But I'm crunching the chicken bones of Life up and licking the grease off my fingers and it's grand, my friend. I feel you sitting next to me and laughing. It's glorious.

Thanks for showing me my tastebuds.

Journal entry by an anonymous Buddy, 1992

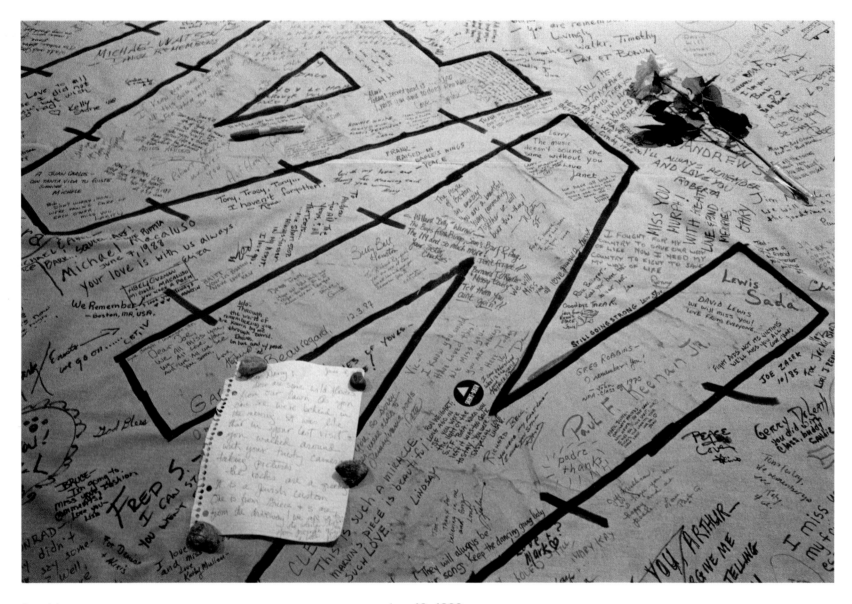

Dear Nancy, June 18, 1988

Here are some wild flowers from our lawn. As you can see, we are behind on the mowing.

It was like that during your last visit as you walked around with your trusty camera taking pictures.

The rocks are a greeting. It is a Jewish custom. One is from Greece and three are from the driveway.

We all go to the white light – you precede us by a little.

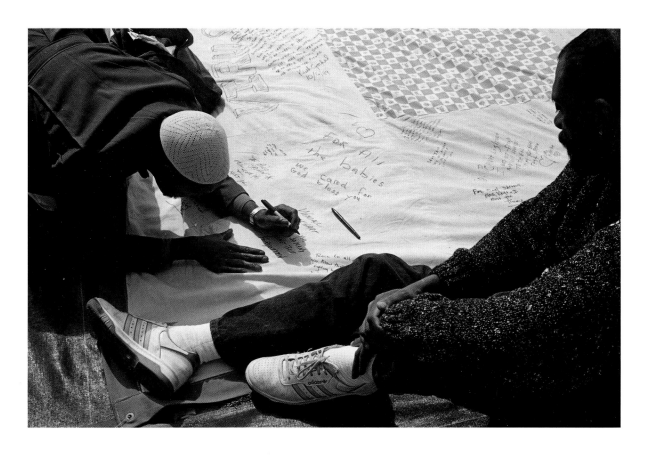

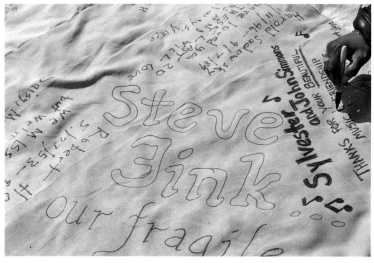

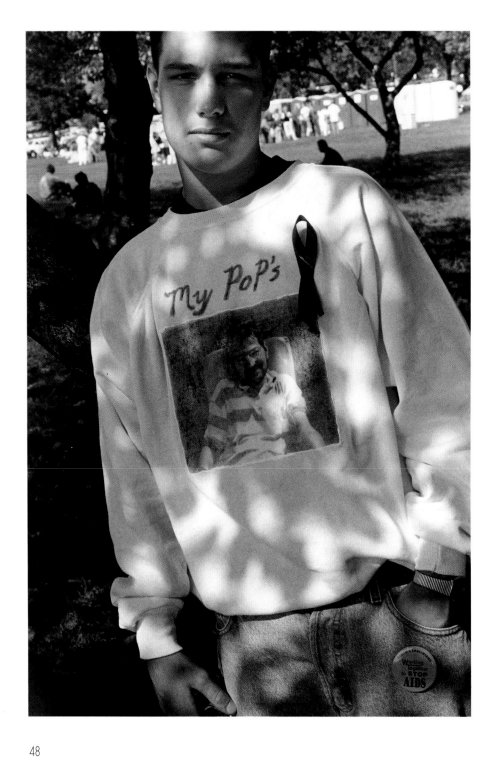

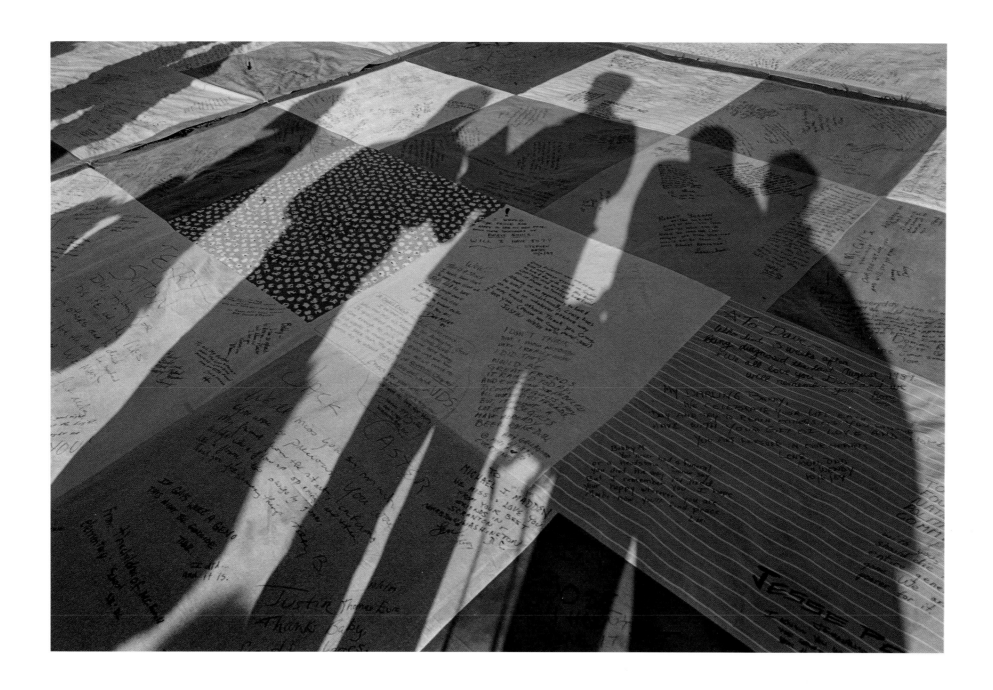

BUDDIES

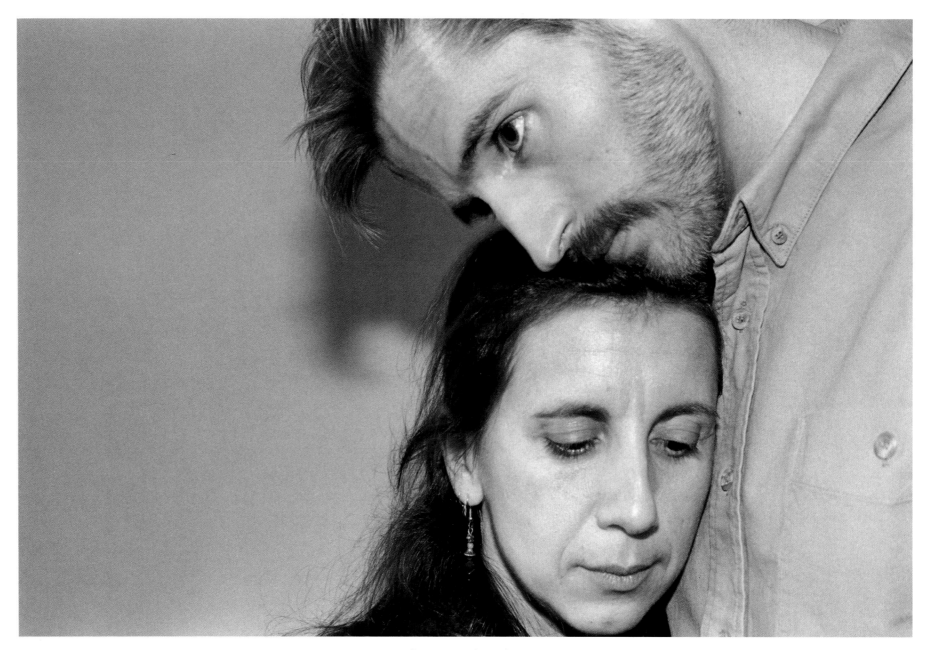

Sharon and Jeremy

What would motivate someone to enter the life of a person with an AIDS diagnosis voluntarily? Or a person with AIDS to invite a stranger into his or her life at what is surely the most intimate time of all? What makes a Buddy relationship possible, and what makes it work?

The following photographs and transcripts provide glimpses into relationships that, in many ways, are not so different from others we've known. In some very fundamental ways, however, they're not at all the same. These men and women are Buddies. They came together not because they're neighbors or play the same sport or necessarily have anything at all in common. They entered each other's lives because one was courageous enough to say "I have AIDS and I need someone *with* me, *for* me," and the other courageous enough to acknowledge that "I'm not sure I have what it takes to be that person, but I want to try."

These are portraits of people in the Buddy Program of the AIDS Action Committee (AAC) of Massachusetts. Similar support programs for people with AIDS (PWAs) exist in cities around the country.

What draws volunteers to a program such as this one? Many have been affected personally by the pandemic; they've lost family members or friends and have a desire to help. Some have no firsthand experience with AIDS; they may view it in a global sense – HIV is a hideous virus and people are persecuted because of it. It's a civil rights issue. Others have children and realize that AIDS could be in their future. The reasons are as diverse as are the volunteers.

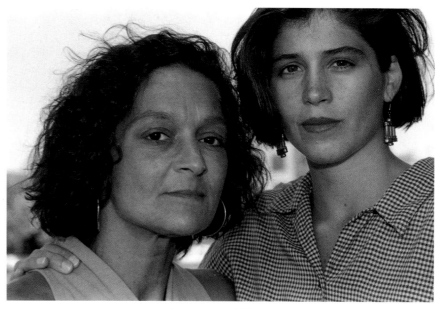

Jennie and Tara

Although there's no question that being a Buddy is difficult, volunteers view the experience not as selflessness or a sacrifice of time or energy. They consider it a privilege. Nearly all describe it as one of the most enriching experiences of their lives.

And why do clients request that a person they don't know enter their world at such a profoundly personal time? When PWAs are asked what they would like in a Buddy, they first adamantly express that what they are *not* looking for is a person to help them die, or someone to take care of them. They want someone to help them live, as independently as possible for as long as possible. They want a person who can enable them to make necessary choices, regarding housing, medical care, legal issues, and other matters. And it's important that it be someone they don't feel they have to take care of, as is frequently the case with others around them. Dying and loss are inevitable and essential elements of this program, but the focus is always and foremost a recognition of what it means to *live* with AIDS.

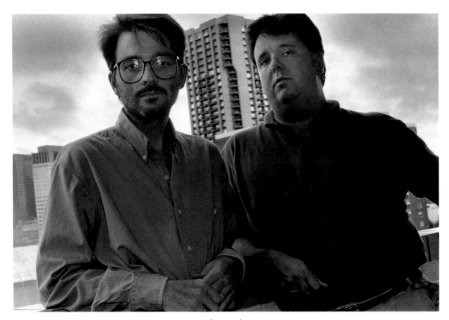

Mel and Jay

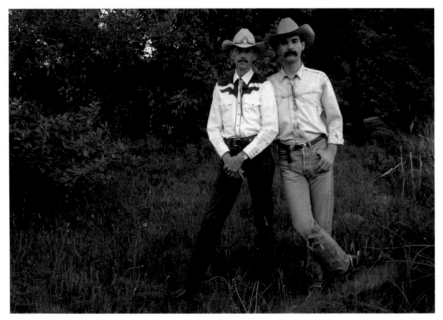

Les and Tim

In the context of the relationship, there isn't one person who gives and another who receives. Both are recipients of an inestimable gift, each richer and each one's life fuller for being a Buddy.

Being a volunteer Buddy means one-to-one involvement, providing emotional and practical support to a person with AIDS. A lot is involved in becoming part of the program, and there's an ongoing process in remaining in a positive Buddy relationship.

During a two weekend training/retreat, potential volunteers have an opportunity and a unique setting in which to evaluate their strengths. They learn that certain characteristics – such as being a good listener, caring, and providing support of various kinds – are valuable in these relationships. Self-knowledge is essential.

Commitment to the program also involves commitment to a support group of volunteers. The meetings, held bimonthly, contribute significantly to the success of both the program and the relationships. Experience has shown that Buddy relationships cannot be managed alone. Through the support groups, program coordinators remain involved in and informed about each relationship. And volunteers are kept in contact with people who have varied life experiences as well as diverse experiences with their Buddies. They offer comfort, challenge, reassurance, and a humbling reminder that volunteers are very ordinary people; they are merely trying to live their lives meaningfully.

From the moment of the program's inception, there has been a continual learning process through the experiences of those involved. The face of AIDS has changed significantly since the early 1980s, and it's essential that the program adjust to and reflect those changes. So while this program has existed for more than ten years, it remains alive through the new perspective and insight of both volunteers and clients.

The client, who may be gone, educates the volunteer. And the volunteer brings knowledge, experiences, and mistakes back to the group, allowing others to learn from them as well. The process is a very cumulative one. This is a program that learns from itself, contributes to itself, sustains itself. Its strength emanates from the giving and receiving on all three sides – the volunteer's, the client's, and the program's.

While the relationships that develop between Buddies most often are described as deep friendships, each doesn't ultimately develop that way, or involve intense discussions about the meaning of life and death. They are unique, defined only by the needs and capabilities of each individual. Still, there is a constant: trust. For the volunteer, it is that very delicate balance between getting close enough to be supportive while remaining distant enough to be objective. For the client, it is the absolute confidence and knowledge that there is a person who can maintain that objectivity, who is part of his life to be, above all, an advocate for him. His Buddy has no expectations, no need to be taken care of. In this sense, the character of the relationship is unlike that of any other. As one volunteer said, it is a shame that everyone in life can't have a Buddy.

People come together as Buddies who may never even know each other otherwise. And if they did meet, they would very likely not connect on any level. They often are from completely different worlds. Yet volunteers seldom request a certain kind of person as a Buddy. "Anyone who needs me" is what is almost always expressed.

Someone is assigned a man or woman in prison as a Buddy, and the first question may well be "What was the crime?" And the answer: "I really don't know. But the reason we're here is that he (she) has AIDS." The minute the volunteer and client meet, the volunteer inevitably says "I don't care what he did; he needs someone to talk to. He needs someone there for him." The same types of questions and doubts arise frequently with assignments to addicts in recovery. And the best way to resolve stereotypes is simply to meet the person. Differences dissolve.

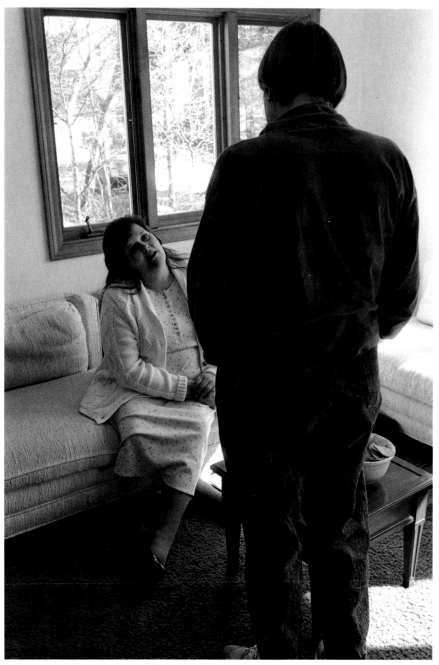

Donna and Elise

The bonds that form, both between Buddies and within support groups, are extraordinary to witness. Even more extraordinary to be a part of. As a volunteer in the Buddy Program for five years, this author is grateful for the ongoing challenge and education of self and others. How blessed I am to have learned to love purely for the sake of loving, without the expectation of being loved back. And not to be so dismayed by the prospect of having to say goodbye that I was too paralyzed to say hello. Perhaps most of all, I am grateful for the constant and powerful reminder of something I once heard – I regret not remembering where or when – that no civilization has in it any element which, in the last analysis, is not the contribution of an individual.

The following transcripts are excerpts from tapes made by Buddies. These were not formal interviews; rather, it was up to each person to decide what was important enough to say, and how best to say it. And Buddies did not read each others transcripts. It was crucial that no one feel compelled to say anything in particular out of concern for the other's reaction. In addition, there are cases in which only the volunteer's transcript appears. This is because many PWAs were not well enough to go through the process. They declined very rapidly and were gone before completing a tape.

Most of the people with AIDS in this photojournal have died. These words and photos honor their memory in a special way, and celebrate the courage of the men and women of Buddy Programs everywhere.

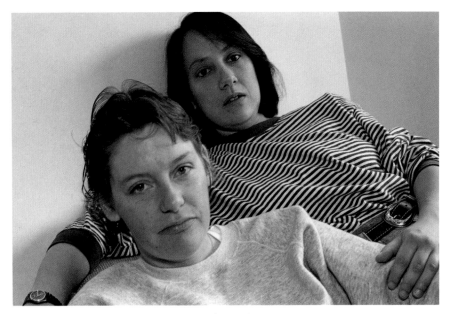

Sandi and Jo

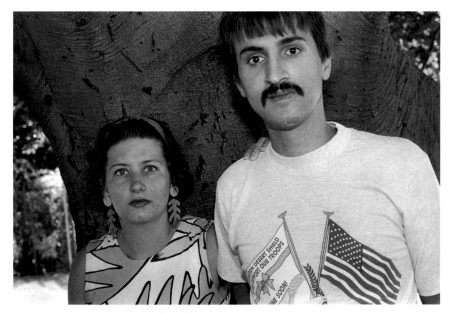

Jan Marie and Jaime

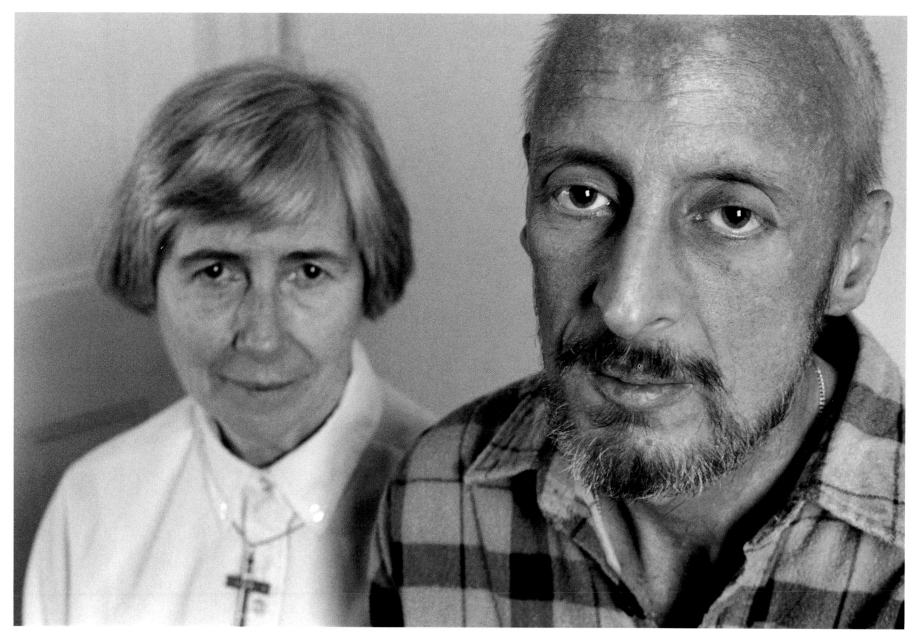

Maryellen & Chad

Ken & Larry

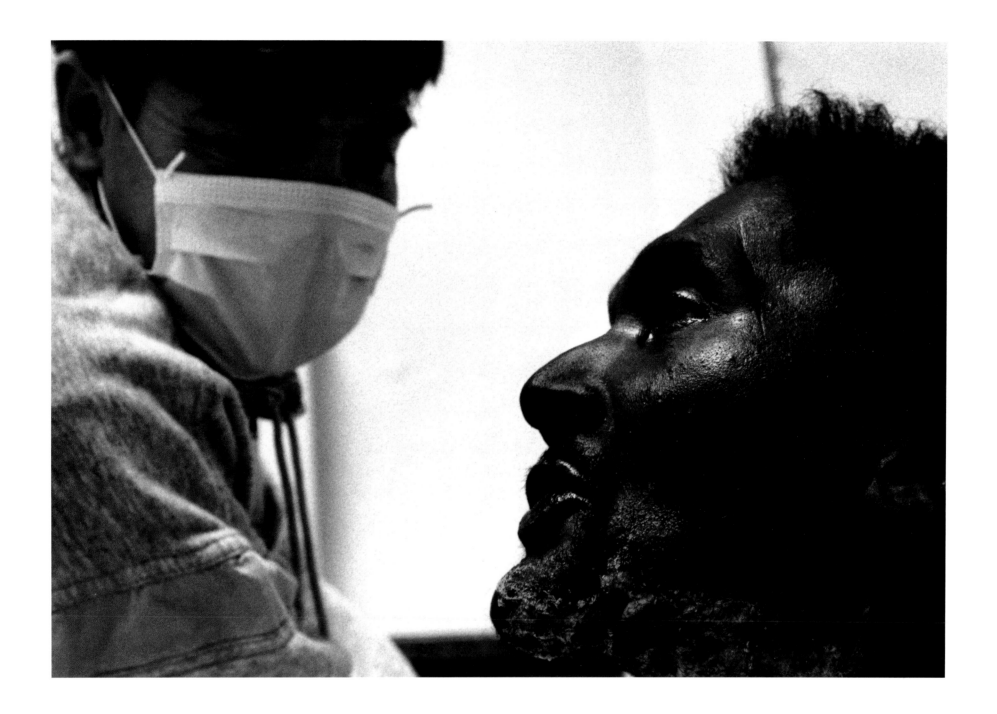

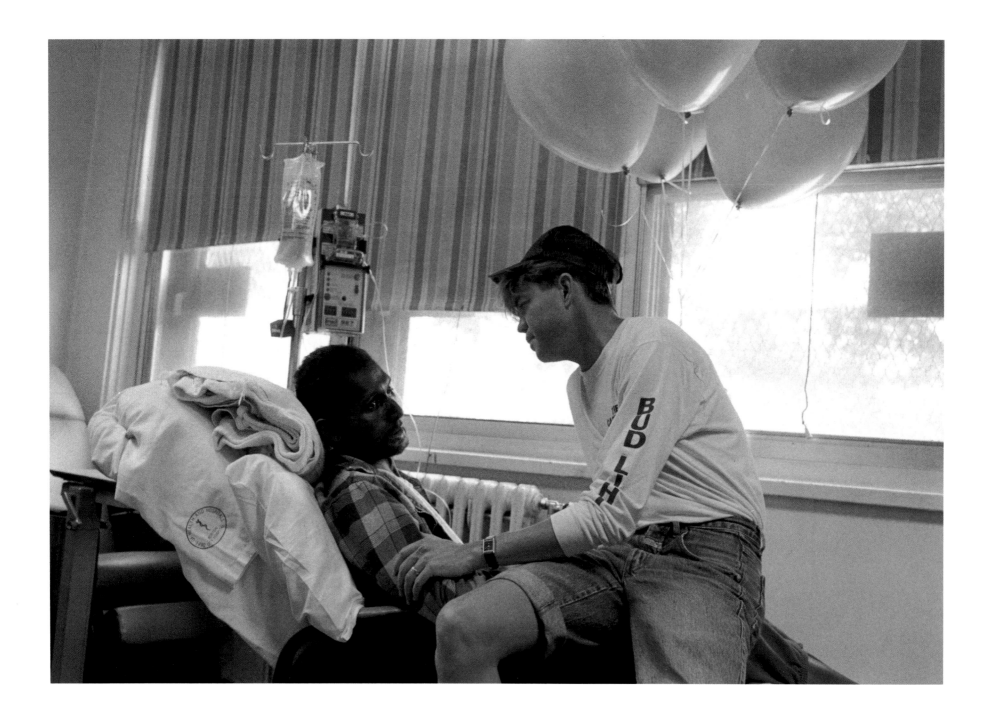

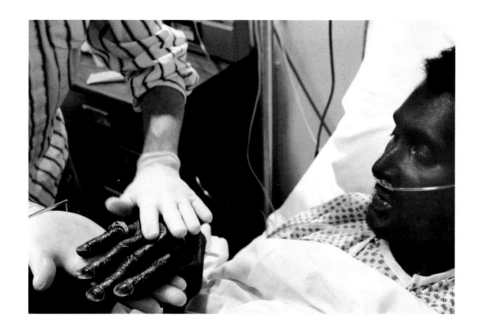 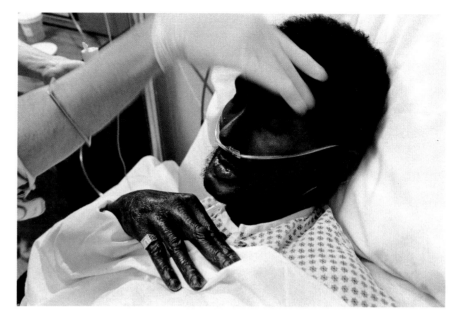

Larry had been hospitalized for two years in a chronic care hospital when we met. All I was told was that he had been an i.v.-drug user and was a straight black man in recovery.

I remember going to see him for the first time. I went to his doorway, all prepared to smile and introduce myself, and there he was on the bed, convulsing. I had never seen anything like that in my life. I stood there for a minute, wondering if he even knew I was there, and something inside pushed me forward. Ken was moaning and shaking, and I was afraid and thinking "I can't do this." He sat up and shook my hand, and I told him I would be back in a couple of days. Then I made a beeline for the door.

A few days went by and I decided to go back and explain to him that I didn't think I could go through with this. I expected to find him the way I had seen him before, but he was sitting up watching television. I introduced myself and he said "Oh, I remember you, but I don't remember much." Then he explained that he had had a portocatheter put in the day we met and had been coming out of the anesthetic. He extended his hand and I looked at those huge hands with gaping scars from his drug use. And I was there to explain to him why I wouldn't be back. Then he started talking about himself. He said what a great thing it is that I'm doing this work, and suddenly I was comfortable and glad that I was there. I thought I'd come back just one more time.

And I came back again and again.

It wasn't long after that that I started realizing why I was doing what I was doing. In the beginning it was because I *wanted* to make a difference. Now it was because I knew I *could*.

Thanksgiving I took Larry out for his first trip home since I had been with him. He was quite a sight – his clothes had cigarette holes in them. We went to his mother's house, in the projects, and that house was so full of love. I looked around at these people who had so little, but they had each other. And so much food! A meal like you'd find in a banquet hall, and love like you'd find in church. I was overwhelmed.

I am a gay white man from an upper middle class family, and here was Larry, a straight black man, an i.v.-drug user. We had no common thread; no similarity of any kind in our lives. Larry had been shot, stabbed; he was from the streets. He had a mother who loved him and through her faith in God loved him unconditionally. Loved life unconditionally. These people were becoming role models, and I was becoming a member of their family.

As time went on, I was learning so much from Larry, emotionally, spiritually, and intellectually that gradually it wasn't me that was giving; it was me that was receiving. Sometimes I'd feel guilty for that.

I remember the day Larry died. His mother called – the hospital said we had to hurry. He had already stopped breathing once that morning and was probably only holding on until we got there. Still, in my mind, I was going to see Larry rally one more time. I really didn't believe I was ever going to lose him.

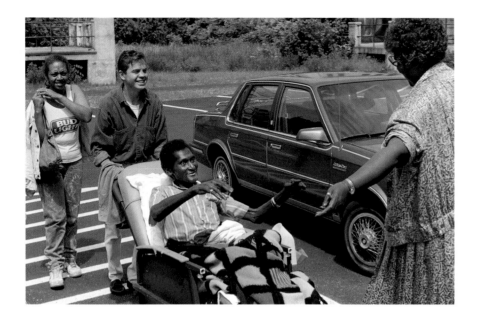

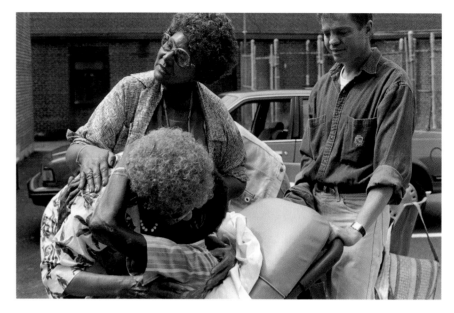

As the afternoon went on, I was even more confident that he was getting better, and I made arrangements to stay overnight at the hospital. I told his mom I was going to go to work to get a couple of things done, and he told the family that it was okay to leave because I was coming back. About fifteen minutes after they left, Larry passed away. I really believe he was waiting for us to go because he was worried about how his death would affect us.

I got back to the hospital and a nurse said "What are you doing here?" I said that I had permission to spend the night with Larry. Then she told me he had died a half hour earlier. Two women from housekeeping had completely stripped the walls of pictures, cards, hats, artwork, etc. Everything was gone. The room smelled of ammonia. Larry was lying there like a number. I asked the housekeepers to leave, closed

the door, knelt down and prayed. I said goodbye to him, wished him well, and peace. And as I held his hand, I realized that my friend, who I thought was invincible, was not.

The day of his funeral, I called his mother and said "Should I meet you at the church?" and she said no, to come to the house and we would go as a family. We sat in the front row together, mourning the loss of our son, brother, friend. I opened the prayer card and she had listed me as a survivor: Larry's friend, confidant, and companion. I was so moved.

Larry was like a brother to me, and his family treated me like that too. The Thanksgiving after he died, we had dinner at his aunt's house. My friend was gone but I had

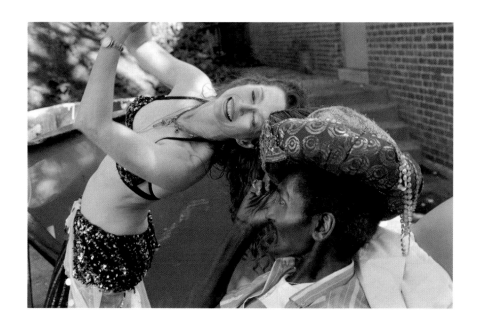

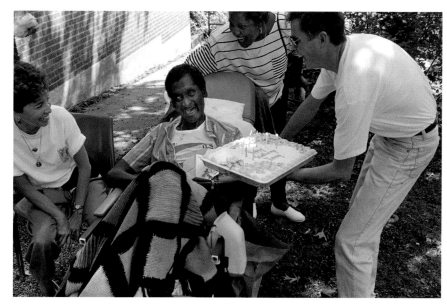

gained a family. I love Larry for·that. I love his mom and his sister for that. Larry is gone, and they still call and check up on me. I still go to family gatherings.

As a Buddy, you receive so much more than you could possibly give. I'm sure I changed the quality of Larry's life, but he changed the quality of mine too. And for two people who were so different to come together, like brothers, closer than friends – I'll never forget him, or the influence he had on my life. I loved him unconditionally, without any prejudices, and that's how he loved me.

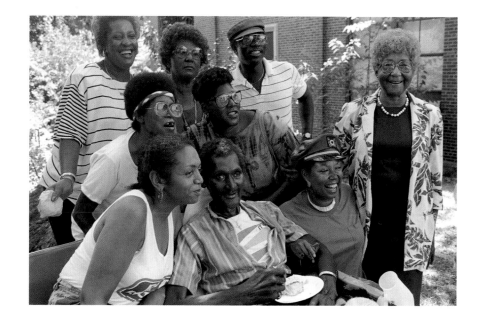

Scott & Joanna

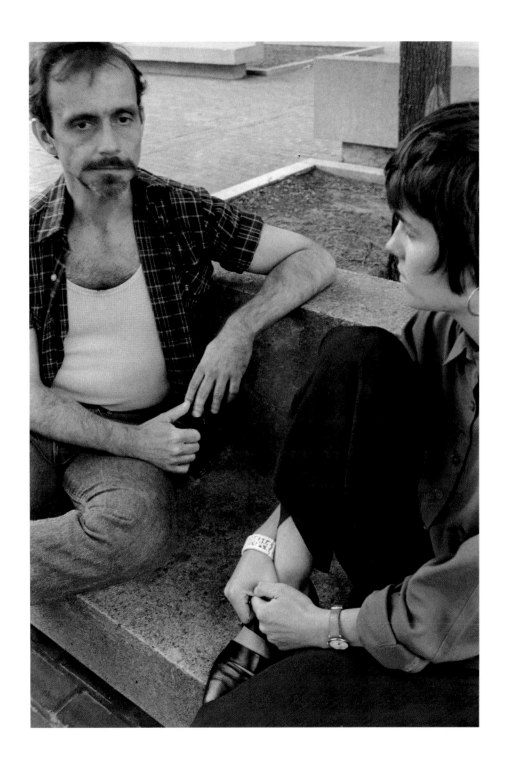

A year ago I met a woman on a street corner. She was my Buddy, and what that was to mean to me, I didn't have the faintest idea.

Having AIDS meant that I felt alone. Although I had lots of support, I still felt completely alone. I guess I thought my Buddy would provide something other people weren't giving me at the time . . . a perspective I was lacking – that of a person who didn't know me well and could look objectively at what was happening.

I realized very early on that what I wanted wasn't a care*taking* relationship but a care*giving* relationship. What I mean is that caretakers are fine, but I'm *alive*. I want to be able to affect other people too. To continue giving. I didn't want to just be the recipient of care.

There are no mistakes in life, as I've learned in my journey through this disease. Still, I was more than a little reluctant to meet with a person who, well, who was a woman. I had thought my Buddy was going to be a "he." I was abused by my mother, so women have always been difficult for me to deal with. But I decided to give it a shot.

Little by little, as we began to trust each other, we began to share ourselves: who we are, outside the issues of AIDS. We've become friends. My feelings for Joanna are very deep. She's helped me see so much – probably a lot that she doesn't even know about, first of all as a *woman* I could trust, and that's meant an awful lot to me, but also as a *person* I could trust.

She was planning to go to Europe in the early part of the summer, and I saw her go back and forth a lot about it – "Do I have a right to have fun? Do I have a right to leave Scott?" And I said "Joanna, I can't experience Europe, financially or physically,

and I want you to do it. Go have a wonderful time." And I went on that trip with her in my head. I was right there beside her.

I don't want to sound overly romantic, but I believe Joanna was placed in my life for a reason. And I believe I was placed in hers for a reason too. I'll never be the same; I don't think she will either.

It's hard to talk about the time when I won't be here anymore. I see the pain on her face. One of the things I hate most about this disease is what it does to the people who care about me. But Joanna and I do talk about it because there's no getting away from it. It's why we were put together. She's told me that sometimes when she leaves me, she breaks down. She says "I'm touched by who you are, what you are, your courage, your determination." I guess what I'm trying to say is that I couldn't have shown her who or what I am if I didn't feel safe enough to do that. There have been many people in my life that I've not been open with because I found it difficult to trust them. From the moment I first spoke to Joanna, I somehow sensed that this was someone I could trust. She was not someone who would hurt me.

I've found that being alone, dying alone in particular, is something I really fear. I gave a workshop on realizing mortality, and one of the questions people asked was "What do you fear most about dying?" And I said "Being alone." I get frightened. I don't know what death means; I don't know where I'm going. But Joanna makes it a little less frightening.

I get angry a lot about this disease. I feel sad. I also feel grateful. I speak for the AIDS Action Committee Speaker's Bureau, and one of the things I say is that in my first thirty-four years of life, I don't think I did much. But AIDS forced me to realize that I don't

have time to fool around anymore. My relationships mean a lot more to me; people mean more; birds and flowers mean more; life means more. I'm appreciating every day. To have what I have around me...I'm very very lucky.

We're never given a script in life, and I believe there's a reason for everything. I always knew I wasn't going to live very long. I knew I wouldn't get old, but I don't think you have to be old to have made a difference. And I feel I've made a difference.

One of the biggest gifts that we can give in life is ourselves, and Joanna has certainly given herself to me. She's not afraid to be human. She's like the sister I wish I'd had. Joanna has made my life much richer, by what she gives and by what she receives. I tell her often how much I feel for her. How much knowing her has meant to me. How much fun it's been. We've laughed, we've cried, we've held each other, we've hurt, we've joked, we've cared. Is there really any more?

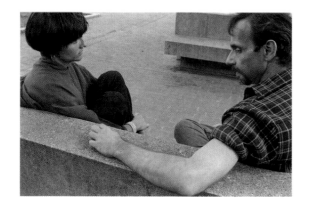 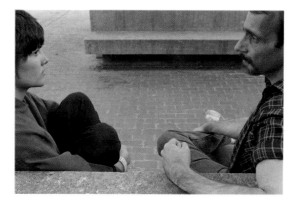 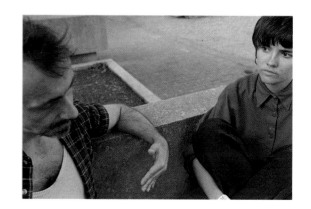

W hen I first made the decision to be a Buddy, I didn't realize how profound it was. It's irrevocable in a sense, and it's good that it is. But it's a very big commitment and I question now my motives for making that commitment.

My life had been affected by AIDS before I became a Buddy, but only indirectly, in the sense that being a citizen of this society and this world and living through the last ten years as an adult, there's no way I could ignore the reality of the disease. But I didn't know anyone personally who had AIDS or had even been affected by it.

Still, I wanted to do something. I learned about the Buddy Program and liked the idea that it was a one-on-one relationship. I like to relate to people on those terms.

There was no way I could have understood what it really meant until I started doing the work and got to know Scott. And now I can't imagine my life without him. He's such an integral part. We're friends – we're really friends. When I went to Paris one summer for a couple of weeks, I was a little scared because he wasn't feeling well. But he was so supportive, saying "Go. Go have a wonderful time. I was there once. Go stroll

along the Seine, go see the Louvre." So I really felt like I was carrying him with me, in my heart and soul. He's a part of me, unlike any other relationship I have in my life. It's hard to explain how that feels.

And I guess sometimes when we get so involved in the day-to-day things like meeting for coffee or going to the movies, it's easy to forget that he's very sick and is going to die. And that's a big reality. There are times I'm devastated by it. Times I can't believe I'm doing it. I'm amazed when I step back and think about how profound, important, scary, and uncertain it is.

When I think that way, I step back and say "Wait a minute, Joanna. *You* could walk away from this if you wanted to." But Scott can't. He wakes up each day with the reality that he has a life-threatening disease. Not even life-threatening. It's a given that it's terminal. And certainly I could walk out my door and fall down three flights of stairs and die, but I don't *know* that. I don't live with that certainty and fear. He does.

In some sense, he gives me the strength to continue. He's struggling with something that's so difficult and irreversible that when I see him, I get strength for my own daily struggles.

At times it's difficult for me to admit how close I feel to him because I'm going to lose him. At first it was almost unbearable. It's not something I can dwell on every day. But I have to face the truth. I was put in his life and he into mine specifically because he has AIDS. We were brought together to share this struggle – for me to be there for him, and for him to share a part of who he is.

I can't really express what it means, our relationship, and what I've learned from him, from myself, and about myself. Being a Buddy is frightening, but it's so worth it. It's unlike anything I've ever done, and Scott is unlike anyone I've ever known. I guess the positive side of his having AIDS, if I can even think about it in those terms, is that I have him in my life.

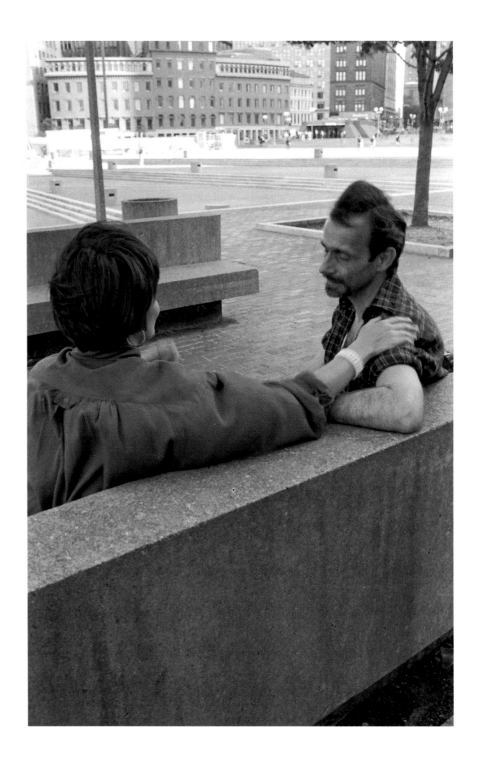

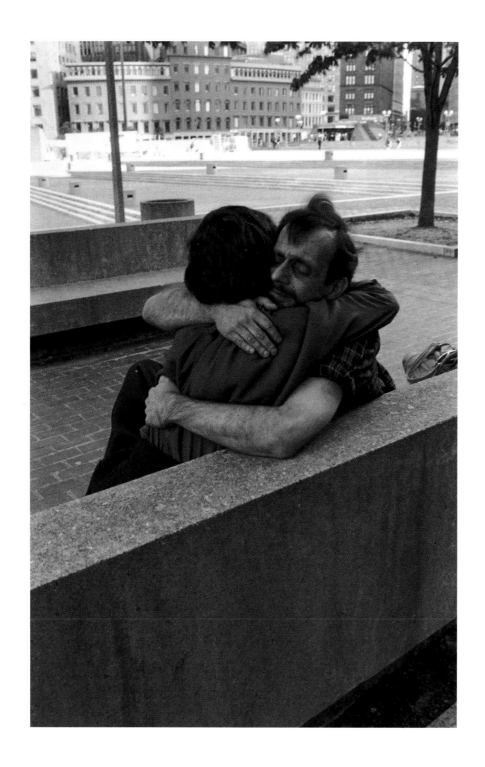

Mark & Paul

I became a Buddy four years ago because so many of my friends in the entertainment field were dying of AIDS, and I felt helpless and impotent. I wanted to do something, to feel that I wasn't just standing on the sidelines, watching and not contributing.

My first Buddy was an alcoholic and drug abuser who virtually committed suicide. He had a great deal of guilt about things he had done to his family while under the influence, and although his family forgave him, he never forgave himself. He deliberately did things that ultimately killed him.

That was a difficult relationship because I don't understand self-destructivness. I'm a very positive person, and I was frustrated that I wasn't able to inject him with the optimism I feel. It was a learning process for me about what one has to accept in people: you do what you can to help without judgment and evangelism about *your* point of view but with acceptance of theirs.

When I met Paul, my current Buddy, I asked him what he wanted from a Buddy. He said he couldn't answer that right off, but he'd think about it and tell me. He never did; we've just gone on with our relationship and it has shaped itself according to his needs.

Paul had a stroke in 1989, which affected part of his brain and his speech patterns. He speaks very slowly. But he feels well physically. He has not, in the two-and-a-half years I've known him, even been in the hospital.

We do very simple things together. During the week I drive him wherever he needs me to. We've also gone to dinner, movies, concerts, and the theater. I try never to say no to Paul. I want him to know he can rely on me. It isn't always possible to do what he needs, but most of the time we find a way to work it out.

Paul has taught me a great deal, particularly about making the most of every day, using the time he has well. He has also taught me the value of silence. He doesn't speak a great deal, partly because of his disability but also because he believes it isn't necessary to fill every minute with words. My tendency is to do the opposite

because of my journalistic training, where it was important to always keep the conversation going and get the story. Paul and I are sometimes very quiet together, which doesn't disturb me anymore. When he does speak, he really has something to say.

We talk about everything, from politics to his health. We've had discussions about death and how he feels about that. He's very organized in that area; he's made out his will and gotten his papers in order. But I think he's going to have a good long life. When I first started as a Buddy, the life expectancy of people with AIDS was eighteen months. It's now been expanded to thirty-six months, maybe longer.

Though he doesn't seem to be able to show a great deal of affection, I know he cares for me. He never goes on a trip without bringing back some small remembrance or souvenir to let me know he was thinking of me while he was gone.

Sometimes Paul is very abrupt with people. He'll walk away without saying goodbye or going through all the formalities that people normally do. But those who know him seem to understand and don't take offense. Very often he will wander away without explaining where he's going, but I've learned that he will return and that I mustn't be overly concerned. I don't expect things that he's perhaps no longer capable of doing.

Becoming a Buddy is one of the wisest decisions I've ever made. It's helped me develop as a person. It has given purpose to my life. It has exposed me to some wonderful, kind, generous, care-giving people that I might not otherwise have met. One tends, reading the newspapers and listening to television these days, to think the world is full of people who are continually assaulting and killing each other. Being a Buddy has shown me that there are many out there who are making sacrifices to help others. I feel very privileged to know these people and to be a part of this.

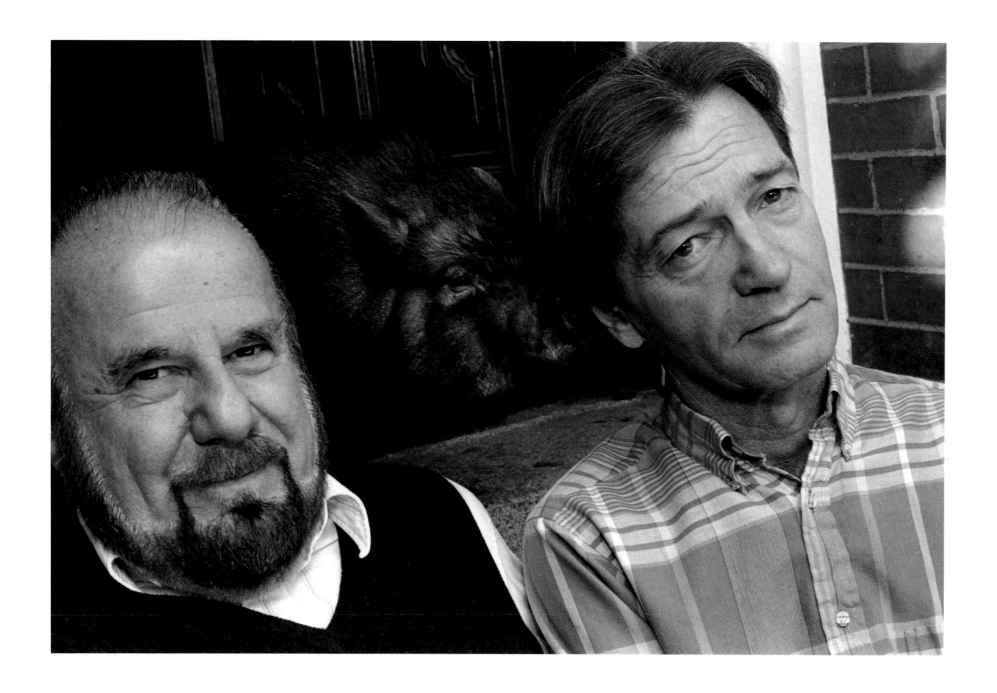

Andrew & LoriBeth

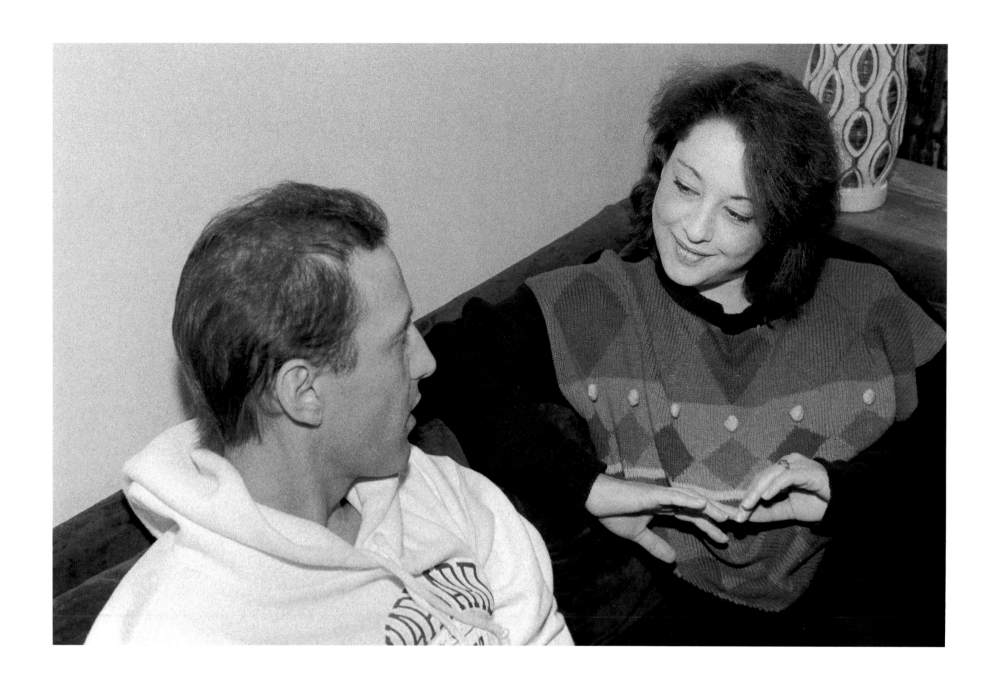

The AIDS Quilt was in town, and my boss told me about it. She had gone to see it and was very affected by it, but it was interesting – she wouldn't eat the food at the exhibit. It might be "contaminated."

At the time I didn't even know what AIDS really was, but when I saw the Quilt, it grabbed me by the throat. So many of the people represented there were my age. I had to do something. Never for one minute did I think that it wasn't people like me; I never had a "them" mentality. It was just people: they're young and they're dead, and I want to do something. That's how it started for me.

The night my Buddy Andrew and I met, I planned to be at his house for an hour or two and I ended up being there for four. I left thinking "Wow, this is great. We really connected."

He later told me he left that same meeting thinking, "Gee, all I have in common with this girl is the earth." He was a guy; I'm a woman. He was Catholic; I'm Jewish. He was from a different culture, a different city, a different world really.

Andrew had slept in mansions and in alleyways. Was it sex? Was it drugs? He could never even figure out how he got the virus. And it's so easy to have judgments about his kind of lifestyle. But underneath all the labels you could put on Andrew was this warm, intelligent, giving human being who could have achieved great things in better circumstances.

I remember him telling me once about people who had deliberately hurt him and losses he had suffered – people who went away or died. In looking back, I realized that was his way of saying "Listen, we're about to start something, and I want to know I can count on you." I think part of that was because a lot of people in his life proved untrustworthy. And through much of his life, he was untrustworthy too. If you yourself can't be trusted, you're probably not going to trust other people.

I got tickets to a Rolling Stones concert and asked if he wanted to go. He was ecstatic. On that day he was calling me every ten minutes to confirm "3:30 at the Park Street station?" But I got there late, and before I even got off the train I saw Andrew standing there, looking up at every train that came into the station, with the saddest look in the world on his face. I went over and said "What's going on with you, Andy?" and he said "I didn't think you were coming."

I was never late again. In my world, people pretty much do what they say they're going to do, but for him, that had never been the case. He described the incredible relief he felt when he saw me get off the train...something I would have taken for granted. It's central to Buddy work that you take into account where someone's coming from, and I could never again be casual about the time.

For many of us, our initial perception of having a Buddy is that it's going to consist of a lot of death and dying talks, Elizabeth Kübler-Ross in action, and exploring the meaning of life and religion. But you find out it's not this tv movie of the week thing. Often it consists of walks and dinners and things everybody does with everybody else.

And most of the time we had a lot of fun! Andrew had a great sense of humor about the disease. Once he said he knew what he was going to be if they found a cure... "a hypochondriac, because the thing I do best is sitting around doctors' offices."

A lot of people have said to me "Why AIDS? Why should someone with that disease have a Buddy?" Well, I think it would be nice if everyone in the world could have a Buddy, but AIDS does present a lot of unique problems. I was looking at someone my own age who was dying, and we don't expect someone thirty-one to be dying. It's also so frustrating medically because you're not just dealing with one terminal illness. You're dealing with a constant vulnerability to any number of infections.

Andrew liked my health. I remember during the worst argument we had, he looked at me and said "It must be nice to have an immune system," and I said "Yeah, it's real nice." I never patronized him or lied to him. And I knew that Andrew didn't wish that I would be sick. He needed my energy and availability. When your lover has AIDS and all your friends have AIDS, there's always a question of "When are they going to leave me?" and "Who's going to go first?" He didn't have those concerns with me. I was a stable force in his life.

His spirit was unbelievable. In March he got diagnosed with Kaposi's Sarcoma of the lung, which is about the most serious thing he could have had. Until then, there was an underlying fear about which of many things would get him. At that point, he met his enemy.

But even then he wouldn't give up. Two weeks before his last hospitalization, he got a car, and I'll never forget him going into the hospital. I saw him and knew he wasn't going to beat it this time. For the first and only time, he said "Lori, I am dying. Do you know that?" And I said yes, I did. He said "I'm dying, but I'm not giving up my car!" That was Andrew.

As strange as it might sound, there were some positive things AIDS gave him too. It brought his lover into his life, as well as me and several other close friends, and it brought his family around him in a way that was very satisfying to him.

He also felt it gave him a kind of respectability that he hadn't had up to that point. He spoke at a number of Buddy trainings, and that made him feel so useful. He was self-conscious about not having much of a formal education, and felt he had never been valued for his knowledge. But to be in front of a room, having every person paying attention to him, was a new thing. Feeling he had something valuable to offer was very important to him.

Buddy work is an incredible opportunity. It's almost banal to say that you get back more than you give, but it's so true. The privilege of standing by someone going through what will probably be the single most crucial time of his life and just having him take your hand is something I can't put into words. One of the best things for me, in doing this work, is that people come from many backgrounds and are there for many reasons, but it's a desire to help and a belief that an individual can make a difference that unites us. I feel privileged to be doing the work with these people.

I think what Andrew got from me, besides my love, was someone who was totally and completely dependable, and someone who never told him what to do. I supported his choices. That's something a Buddy brings to the relationship that few people can bring. I was there to listen, to give him information if I could, and to really be on his side, standing by him. Our friendship grew into a very deep one, for both of us.

And what I got from him? I got to know him. He's not someone I would have met in any other way in my life. We were so different. People ask "Was it worth it?" and absolutely, it was. As sad as it is that he is gone, it was worth all my tears. I would do it over again in a second. I've never known anyone who loved life as much as Andrew did. Sometimes I came home thinking "I don't believe I would love this planet as much if some of the things that happened to him, happened to me." And yet he wasn't bitter.

It's really too bad that Andrew had to die. The world is missing a lot of energy and a great deal of humor without him in it. He just loved being here and didn't want to go.

Lance & Owen

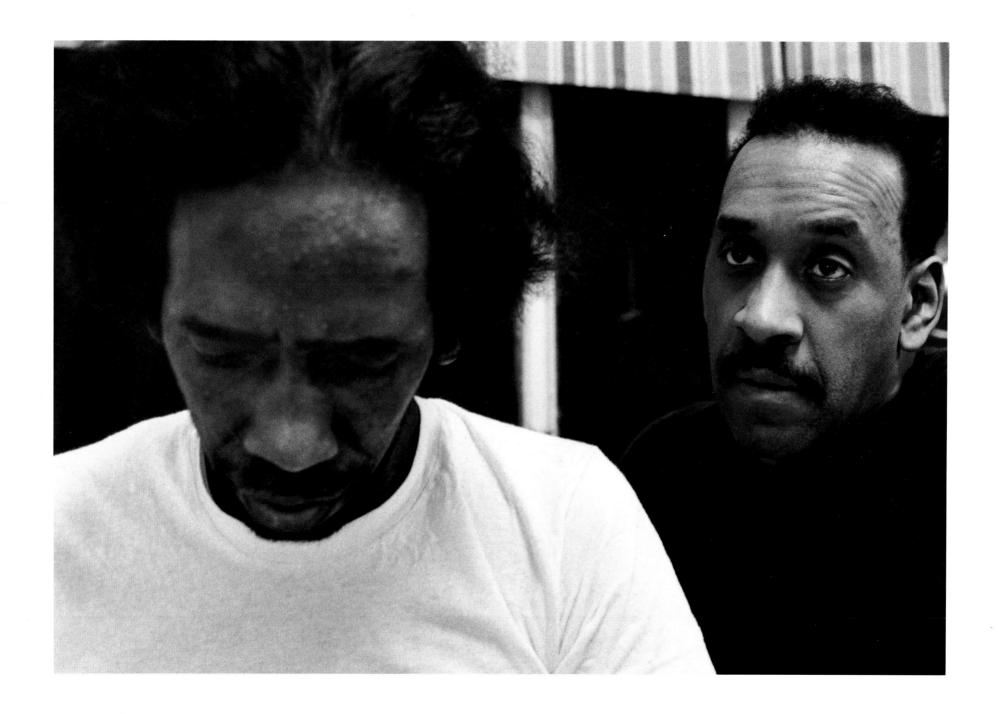

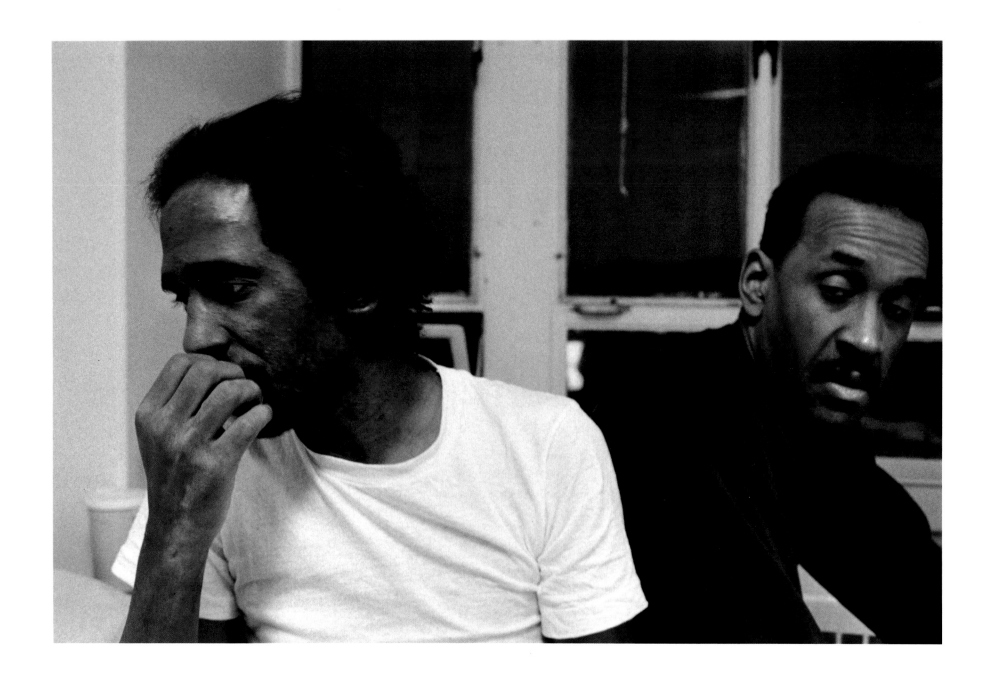

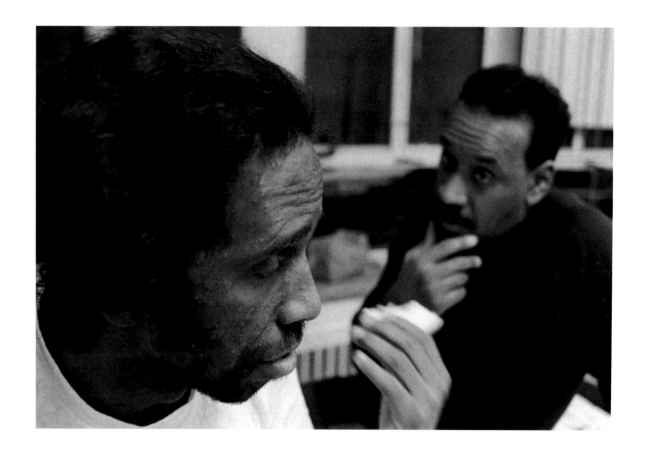

It's hard to start – hard to think about some of these things. In December of 1988, Lance was described to me and I was asked what I thought. He had been an i.v.-drug user for much of his life and was in prison off and on for about eight years.

When we met, he was in prison, and we both had our guards up a bit. He was a sharp guy – knew what he wanted and how to get it. He said "You know, I noticed that sometimes my friend Ed's Buddy brings him things. How much allowance do you get for that?" I told him I didn't get anything, and he said "How are we going to work out how you'll bring me things?" I said "I don't think that's going to be a problem. I'm just not going to bring you anything." And we both laughed.

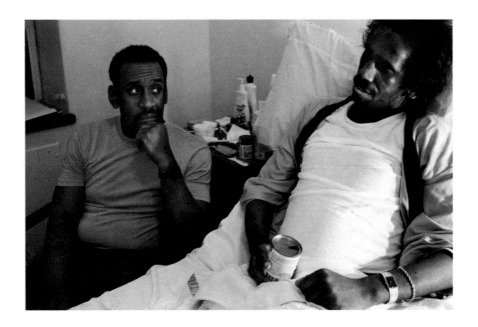 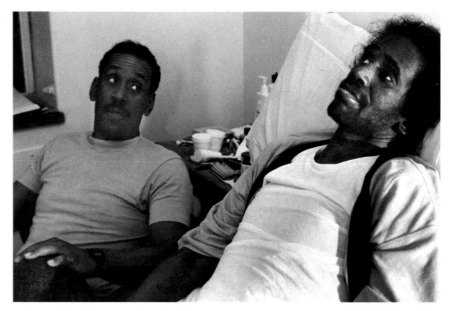

We were as different as night and day. The two of us would probably never have met if not for his illness, and if we had, we would never have hooked up because our backgrounds and values were so different. I remember him telling one of his friends I was the squarest guy he'd ever met. At first that hurt, but then I realized that anyone who was married and had a family and obligations was square to him. It was as simple as that. It wasn't that I was bad, just square. He was a player. From the time he was nine years old, Lance was out all night, hanging out at bus terminals and brushing lint off of people for tips. He was an operator. He knew what he needed and how to get it, and he went about it the best way he could. And to have responsibilities was ridiculous, nonsensical, a waste of time. He didn't disrespect it; it just wasn't for him.

But it didn't matter that our values were different, our lifestyles were different, our goals were different. We respected and loved each other. It wasn't that we agreed with what the other was doing; we just accepted that that's where the other person was at that point.

As different as we were, there was an understanding deep within each of us for the other. Many times we didn't even have to say what we felt; a look would convey it.

When we began meeting, he sometimes had to get out to appointments and still get back to pre-release on time so he wouldn't jeopardize further passes. He was doing

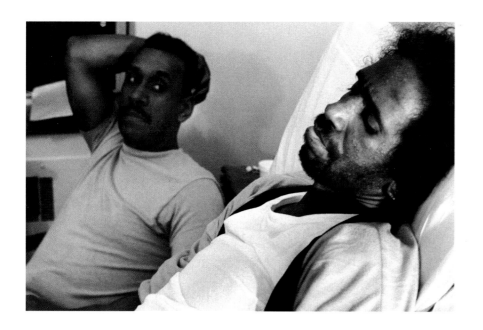
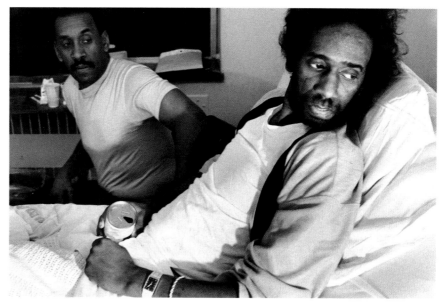

the best he could, but sometimes he'd miss a bus and have to walk. He had a lot of inner strength but it got tougher later on, when his muscles wouldn't react the way they used to.

Once he was getting dressed to go to the movies with me while I went to the nurses' station to pick up his pass. When I came back, he was sitting on the floor. I was wondering what had happened, and he just looked up and began to laugh. He said he had taken a couple of steps backward, couldn't stop and had fallen, then couldn't get up. He was able to laugh about that because he knew I would be coming back to help him.

We started talking about whether we were going to do these photos for this book, and he had a bad rash on his face. I tried to ease his mind by saying that it didn't bother me (and of course it didn't because I wasn't the one with the rash), but I had to realize that he was, again, a player. He wanted to look good. So for him to agree to the photos was quite a courageous step. He was allowing himself to be vulnerable in the hope that someone might be helped in some way. It was very moving.

We got to be honest with each other. He gave me more trust than I necessarily cared to have. He would ask my opinion on things and I knew that many times he opted for the way I thought. That carried a lot of weight, knowing that he listened to me and cared what I had to say. He honored me by that and made me feel so much closer to him.

Lance would speak his mind and it was up to you to deal with it or not. Not many people are comfortable with that. He could seemingly be very cold. He could also be warm and sensitive, as much as he wouldn't admit it. Almost every time we went out, if it was near a holiday such as Mother's Day, he would pick up something for his mother. At least half the time we were out, he would have to stop to see her. He would act like it was just casual, but he wanted to be with his mother. Just to see her, to hold her.

Sometimes in this work you wonder whether you're being useful at all, and you question yourself over and over again. I would wonder if there was any purpose in my going to the hospital. I knew we had a good time but I wasn't sure I was adding anything to his life.

Then once I went to visit him at the hospital and was told that he had gone down to X-ray. I was concerned about why he was there. My denial was very strong regarding his condition being terminal. I just wasn't going to accept it. I went to X-ray and asked for him, but was told he wasn't there. Then as I headed back up to his floor, I happened to glance down one of the corridors.

There was a sad picture – a very thin person halfway down the otherwise empty corridor, in a wheelchair, slumped over. It was Lance. I walked toward him and as I got close, he raised his head and said "I knew you would come." And it just filled me with so much joy that he knew he could count on me. When he said "I knew you would come," it took away all doubt that I was making a difference for him. It seemed that he felt immediately better by my being there. I could see a complete change.

The day he died, I had two meetings in Boston that morning and was going to see him in the afternoon. He knew I'd be there. When I went in the room, his father said "He's not doing very well." I went over to the bed and Lance reached up to shake hands. His father said that was amazing; he hadn't acknowledged anyone else's presence all day, but he actually reached up to greet me. Five minutes later he died, and we realized that he had struggled through pain to say goodbye to me and thank me. I thank him.

I've said a few times that we were very very different, from our backgrounds to the things that amused us to the movies we would choose. But he was filling out a survey one day, and one part was about your relationship with your Buddy, your lifestyle, your background, the things you liked, the things you didn't like, and so forth. The coordinator of the program knew both of us, and she was amazed reading his answers. From what Lance said, you would think we were twins. He could see no differences between us. Our personalities meshed, and it seemed like we became one, thought as one, and felt as one.

One thing I remember saying at the funeral was that we were closer than brothers. I love Lance; I love him today as I loved him when he was alive. He still lives in me, and I'll miss him until I see him again. Being with him was one of the best experiences of my life. I thank God for the opportunity to share as much as we shared and love the way we loved. He's my brother, my friend, my other half. I'm honored to have known him.

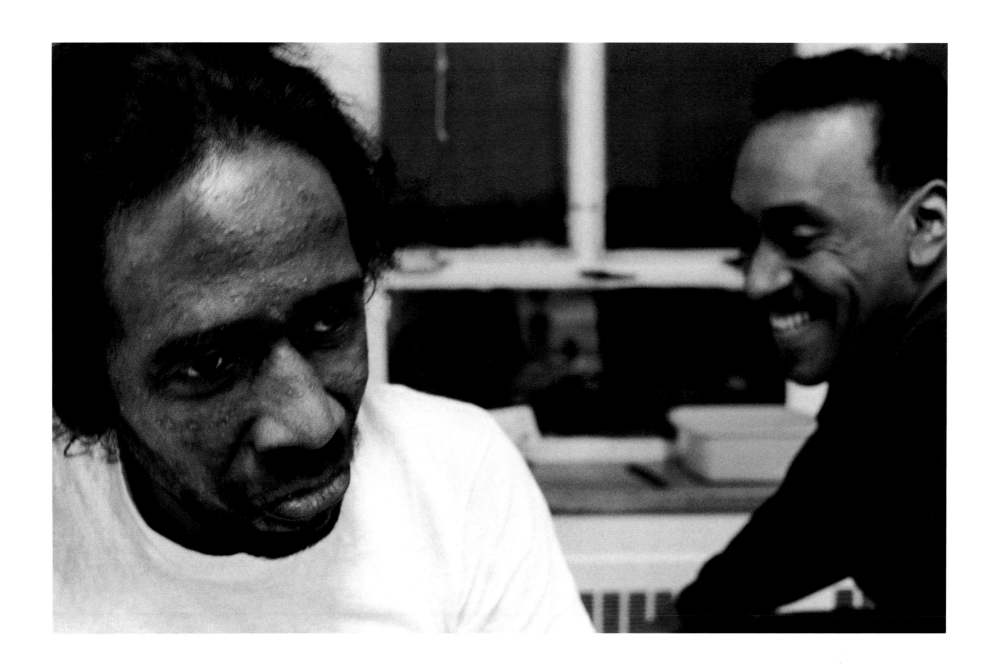

Thom & Alan

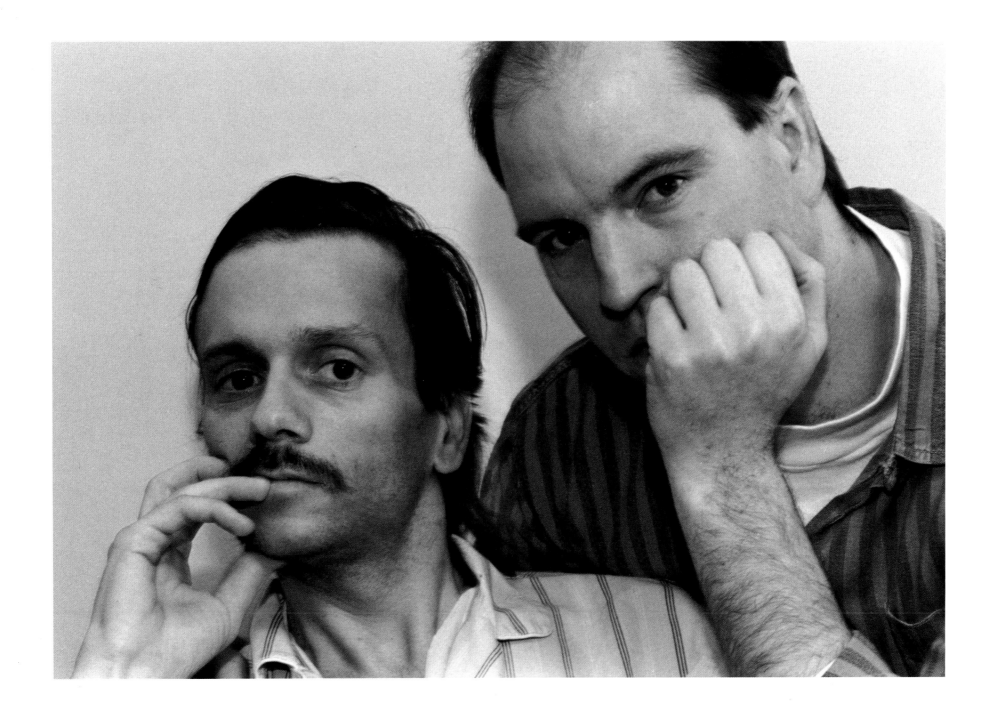

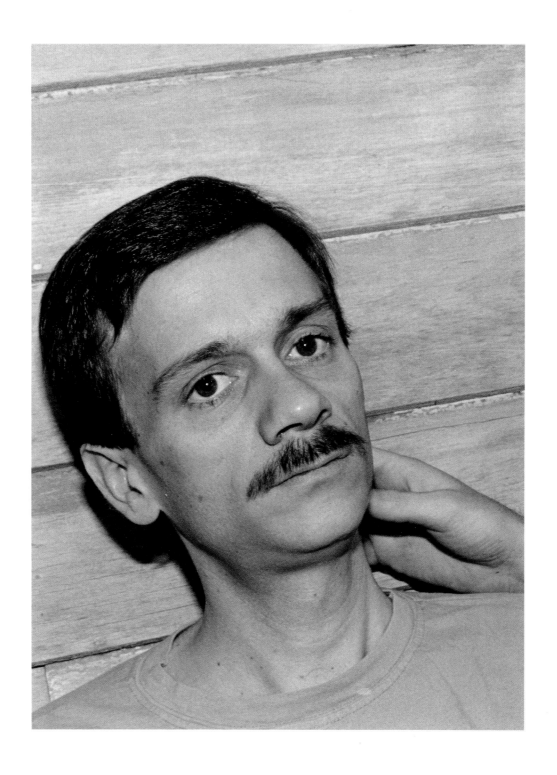

I will never forget the day I learned I had full-blown AIDS. My whole world changed. And after what I've gone through since then, I don't think there's much left of the person I was before.

I was petrified at first. My mother, sister, and I kept things to ourselves for about a year and a half out of fear of losing friends. I stayed in and wouldn't even take phone calls. We just didn't know what to expect. Now I'm beginning my fourth year. I have lost my antique store and my drapery workroom. I have chronic diarrhea, which means I can't go out of the house: I can't go shopping, I can't go out to eat, I can't go visit friends.

I'm down to 108 pounds. I've lost a third of my total body weight. I lose so much so fast, I'm in the hospital almost every two weeks to be hydrated. The cluster and migraine headaches, the night sweats, the high fevers, everything in my immune system has deteriorated so much that anything can, and does, go wrong.

Recently I developed CMV retinitis, I had to have a catheter put in my chest, and I had eye surgery because the retina detached and was full of holes. This disease is taking everything. Like a Pac Man game, just one bite after another. It strips away all your dignity and hope. For some people, it happens quickly, but for many, it's long months of suffering, medications, trials, and hopes that something will make a difference.

But I think the emotional part may be worse than the physical part. It's been very difficult for my family. You need someone around, but you're afraid to look for more support. You just keep asking and asking and taking and taking. It seems like that to me anyway, and it must seem like that to other people as well.

Two years ago I asked for a Buddy, and it was the best thing I've ever done. If not for Alan and my family and friends sticking by me, I don't think I would have made it this far. Their love is what I hold dearest in the world. Alan is wonderful, not just to me but to the whole family. He calls nearly every day. When I need information, he gets it; when I need a ride somewhere, he takes me. And it's such a relief to have someone like him to bounce things off of. With Alan, the relationship is 100 percent support through everything. It's spiritual as well as a realistic base.

It's interesting how life goes on, no matter what. I hear people talking about what they're going to wear to a dinner party and I think how nice it must be to worry about things like that. So many out there struggle just to get through the day and wonder if they're going to live to see the next day. People take so much for granted. I don't do that anymore. Little things matter, not big ones — like fresh air, the trees budding, sitting outside, or getting in the car and going for a ride. I treasure all of that now in a way that I never did before.

I'm not giving up hope. At first I kept saying I was dying of AIDS, but for the past three years, I've said I'm living with AIDS. To do that, you have to maintain a sense of humor. You've got to joke about it. It's so serious, but your thinking has to change or it will eat you up.

I guess my biggest goal at this point would be to help others — to give lectures on what AIDS does. If I could enable even one person to see how it tortures you, I would feel I've accomplished something. Unfortunately I can't go out and do those things. But if I could help even one person admit that this could happen to them, I would be giving something back. It affects everybody: gay, straight, female, male, babies, teenagers, *everybody*. For most people, unless they really see, I don't think they understand.

Sometimes I reach the point of wondering "Have I had enough?" And in some ways, I feel I have. I don't have the energy to go on by myself; my family and friends are the ones holding me up. I believe I can guide them through this crisis too. It's almost an obligation now, to help them after they've done so much for me. The body may die but the energy and the spirit within me will be around forever.

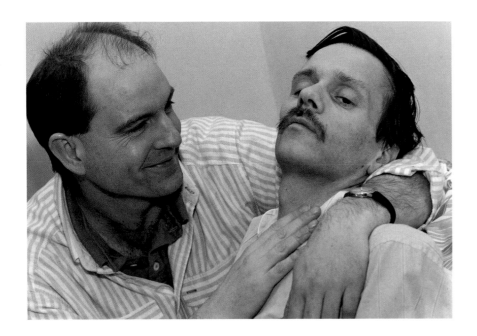 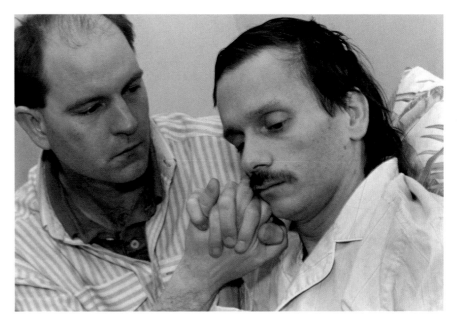

I nitially I felt a little arrogant about the emotional expectations of being a Buddy. I knew I was getting into a relationship with someone who wasn't going to be around forever, so I didn't consider getting emotionally attached. Why would I let that happen when eventually he was going to die? I'm not stupid.

It's hard to explain the reality of it to people who haven't done this type of work. They think that since I knew what I was getting myself into, there shouldn't be a problem. Just set boundaries and don't get overly involved. That was *my* response too, when my friend's Buddy died in 1989. Intellectually, that's not so unreasonable.

I just didn't count on the feelings that snuck up on me.

I don't know when or where I began to love Thom and all that he was to me. I do remember one Saturday eight weeks before he died. He was scheduled for brain surgery the following Monday and I had gone into the hospital that morning with a quilt I was making. Thom had taught me how. Nothing extraordinary happened all day but I had a feeling of great peace and contentment. He was alone in the room so I spread my quilt on the next bed, and as I worked, we would talk or he would nod off a little.

His mom and brother came later and we all had dinner together. After they left, I was sitting next to his bed holding his hand, preparing to go, when he turned to me and said, "You know, if all this is getting to be too much for you, you don't have to come

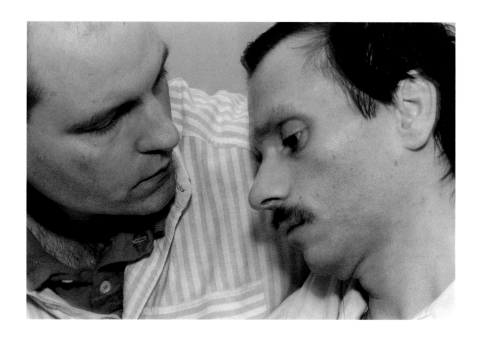

I think one of the hardest parts was having to watch his deterioration. It was horrible witnessing another human being's suffering, particularly one I loved so much. Pictures of him when we met are a startling contrast to what he looked like at the end.

The day he died, he had been in a coma for about six hours, and his breathing was getting slower and shallower. It wasn't until that point that I admitted "Oh my God, it's really going to happen." That's how much in denial I was. I wanted to leave, thinking that if I wasn't there, somehow it wouldn't happen. I didn't want to watch him die and feel so impotent and useless.

And despite the fact that we knew he was going, that knowledge didn't help when it finally happened. Nothing prepared me for the actuality of his death. I had thought that maybe my life would go on without much change and that I could walk away without too many scars. I was wrong. I've been devastated by what this disease did to him and by the fact that all the love and caring we gave him couldn't prevent the out-come. I also keep thinking that it could have been me. It could still be me.

In spite of all of that, I feel extremely honored to have been allowed into Thom's life and his family's, and totally accepted by them during this most vulnerable and intimate time. That's what I focus on when I begin to feel claustrophobic about the world of AIDS. I love my Buddy and miss him terribly.

But as enriching and rewarding as our relationship was, I can't see myself ever being a Buddy again. I know I have to be involved on some level, such as speaking at Buddy orientations, because I would hate to think that what I learned was wasted. But I grew so attached to Thom that I can't conceive of putting myself in that position again with anyone else. Our relationship, to me, was perfect, and the sense of loss is still so great that some days I can hardly bear it. With this relationship came a pain I hadn't known before. I feel as if someone's taken my rose-colored glasses, and I want them back.

back." He was crying and gripping my hand hard. I was so moved that initially I couldn't say anything, but finally I was able to say "Thom, I'm not going anywhere." The fact that he was giving me the option of getting out of that mess two days before his brain surgery still overwhelms me. His kindness was immeasurable.

Thom didn't talk much about dying. He would always say, "If something happens to me." But at the same time, he was practical about what would happen "after." He picked out his casket and formalized details about what music was to be played, etc. He even had me videotape him telling his family goodbye and how much they meant to him, which he wanted them to see after his passing.

Carole & Michael

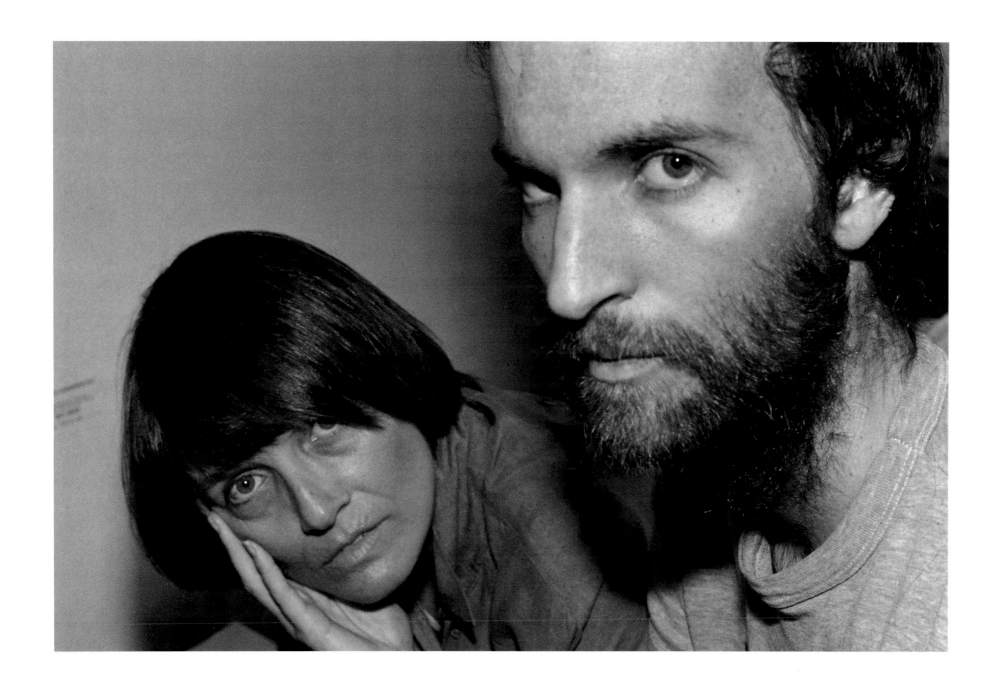

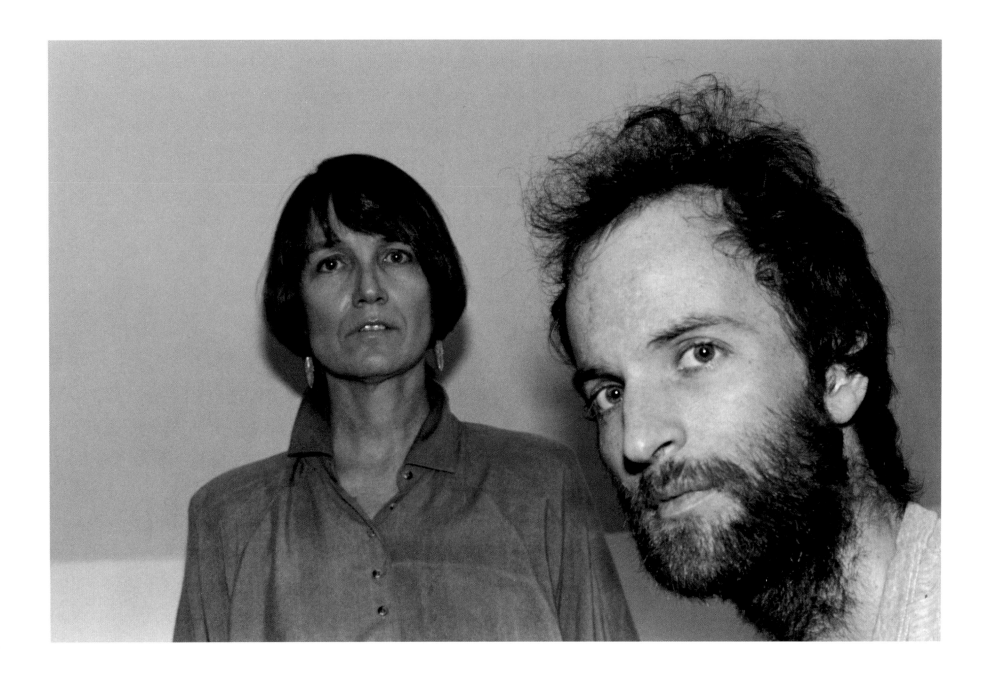

I hadn't known anyone with AIDS before meeting my former lover's brother, and I'm embarrassed to admit that I was afraid of having him eat in my house. This was in 1986. He did eat with us, but I thought of disposing of the dishes afterward.

When he died, I wanted to do something. I had heard of the Buddy Program, and that's how I got hooked up with Michael.

Nothing I ever did with Michael seemed like enough. I always felt I should be doing more. Especially near the end, when he was getting sicker and having greater needs and, I think, having fewer people in his life, because he wasn't capable of going out and being with friends. And people sort of fall off as you get sicker.

We went on tv together and one of the statements he made was "I don't think AIDS is going to kill me. I think if I die from anything, it will be from the bureaucracy." As time went on and he got sicker, I think he felt even more abandoned by the bureaucracy.

Michael really trusted me, and I find that amazing. We went together to his therapist to talk about his death and discuss filling out the form for medical proxy (the person who would make medical decisions for him should he not be able to do that for himself). And he decided to name me. Later we sat on his bed and went over all of it together. At the end there's a little place for "And what if your wishes conflict with your proxy's wishes?" He checked that his proxy's wishes – my wishes – should go into effect.

It completely blew me away that he would put that much trust in me, in our relationship, in my caring about him and doing what I thought he would really want. The irony of it is that I went back to my support group and talked about how profound this was, and my God, how am I going to make these decisions for him in the end? And they all said "The chances of this happening are a million to one. People pretty much just die in the hospital." But as it turned out, I had to completely overrule his wishes and make decisions totally unlike the ones we made together sitting on the bed that day.

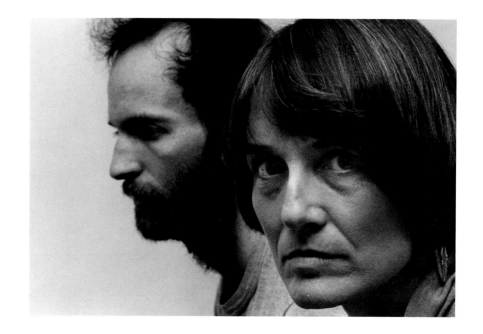

I was supposed to be Michael's emotional support person, and I was, but once in a while that shifted and he was mine. When I took on this responsibility, my life was very quiet. I had an exceedingly peaceful job, and I had a lot to give. But this "assignment" lasted four years, and my life changed dramatically. Toward the end, you give more and more of your time and energy, and it *takes* more time and energy. I mean, in the beginning it's fun – movies and dinners. In the end, he's very sick and dying, and I spend time with him because these are my last few days, weeks, months with him. And I want to spend that time, but my life has become really complicated.

The night Michael died, everyone close to him knew it was going to happen. His brother got up at 3:00 am and spoke to him, held him in his arms, and told him he loved him. Then he covered him up with the cover that had been on Michael's mother's bed when she died, and as soon as he did that, Michael died.

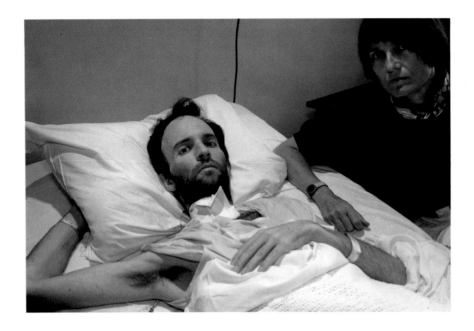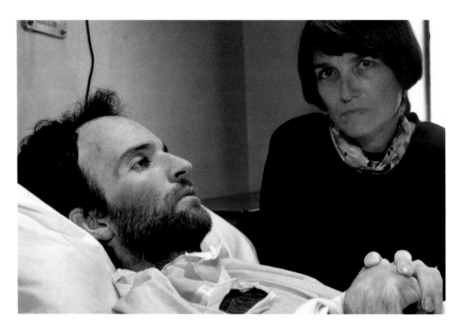

His brother called me at 3:00 in the morning and told me Michael was gone. I was relieved.

Since his death, I am really angry – about the disease, about how it's taking people away, about how it took him away. I am outraged; I am furious. He was thirty-one years old. I feel like what we're doing is nothing, and I know that's all just an emotional reaction, but it feels like less than a drop in the bucket.

It's kind of hard for me to talk about the memorial service. Michael was cremated. At first, I felt horrible about that. No one close to me was ever cremated. I felt like his beautiful body was completely demolished, and he was nothing anymore. We had a small service on the beach, with a dancer and a singer. We were all facing the ocean. And as "The Wind Beneath My Wings" was being sung and the dancer was dancing, a bird flew over the dancer and hovered and just stayed with its wings out-stretched. The wind was holding it up. I felt like Michael was there.

I spoke and cried. I had prepared nothing, all I did was talk about Michael and my love for him, who he was to me, what he gave me that will stay with me for the rest of my life. Then we went up on the beach and scattered his ashes. And again I had that feeling: "Oh God, is this all that Michael is now? These little pieces of white stuff on the beach?" I hated that image.

Then a friend of mine spoke at a meeting, about his son who had died at the age of four. His son had always been afraid of the dark. And he said sometimes he wants to dig him up and take him out of the dark and into the light. For the first time I thought how glad I was that Michael was cremated and now he's little pieces of light. I don't have to think about his body decaying; I can think about him being pure light. That was a relief.

After Michael died, I was going through all these cards that he made me. One of them said "More love than you can imagine," and I think that's what we were to each other. More love than you can imagine.

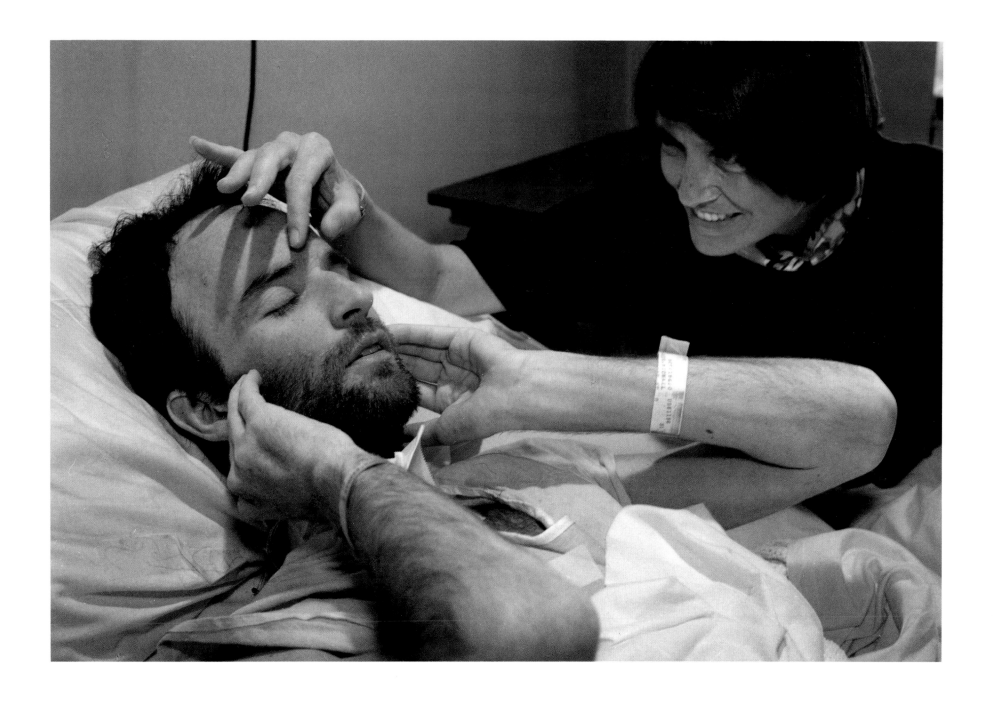

John & Fernando

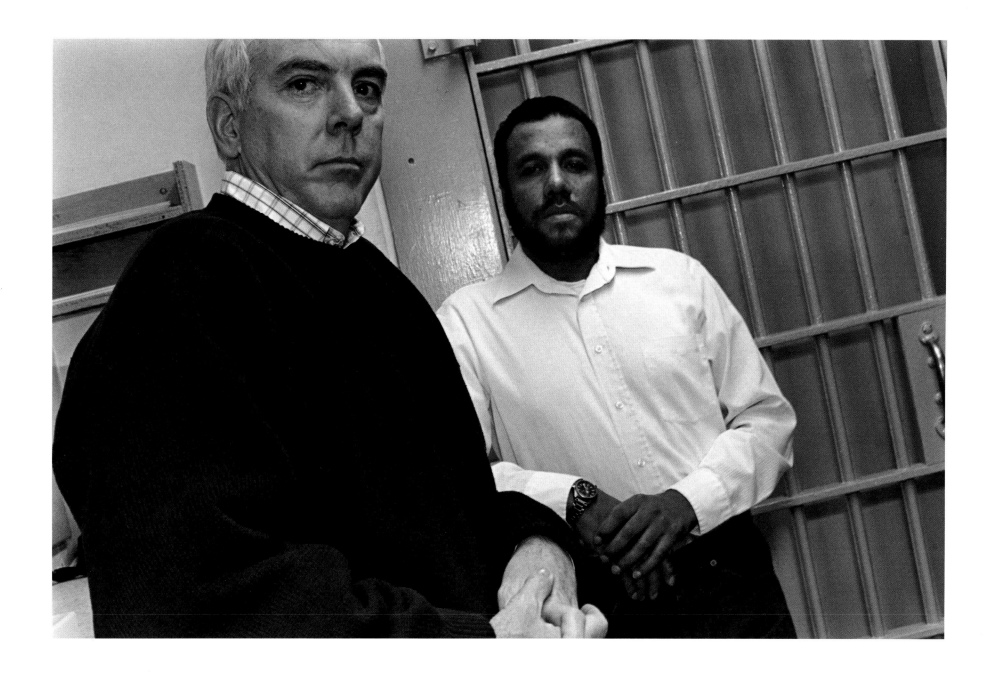

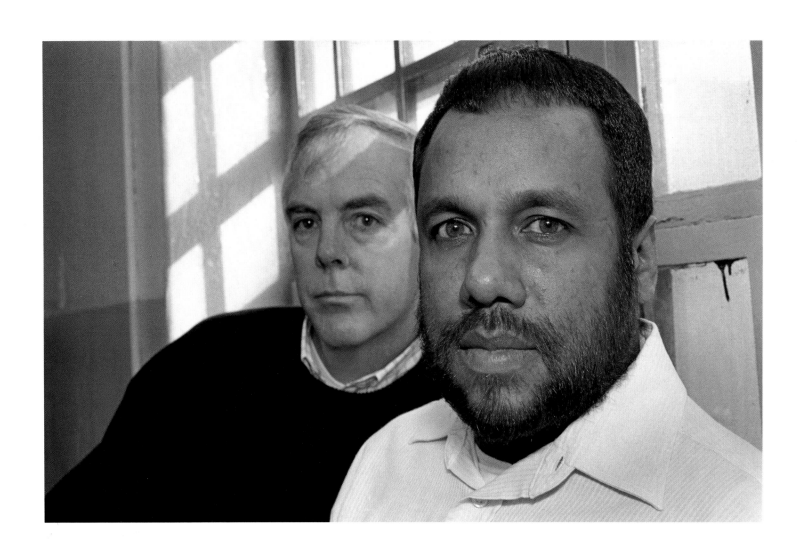

When I was first assigned to Fernando, in September of '88, he was living in a wing of a hospital where the Department of Corrections (DOC) had, in a moment of early epidemic panic, put the prisoners that it knew had AIDS. Other prisoners with a medical need were there as well, but anyone with AIDS – healthy or sick – was placed there.

That's where I first met Fernando, and he struck me as a very quiet, polite man. He is Puerto Rican and short and, when I met him, was heavy. At that time, in that place, there were no amenities for the prisoners that they would have had if they had been in a regular jail, so the DOC allowed us to bring them food from the outside. We could bring any food items we wanted as long as the guards could inspect them first. And cigarettes. This seems like so long ago – forever, in light of all we have been through since then.

Fernando was healthy when we met, then he went in and out of serious illness for the next eighteen months. Maybe it was from living in the hospital or from his disease, or a combination of the two, but he came down with all the classic opportunistic infections: repeated bouts of pneumonia, thrush, neuropathy, sores, lesions, etc. As all of this was going on, I was seeing him two or three times a week for an hour at a time.

One of the central themes to our relationship was that we always had to talk without privacy. We were always under guard. The hospital visiting room is unbelievably cold, dirty, and impersonal. There was a loud tv on in the corner but we always kept it on because it allowed us to talk closely in low tones and the sound would mask our voices from the guards.

As I'm writing this, I'm pounding these keys with such anger at the way he and I were treated. I haven't thought about that hospital in detail for a long time. The physical dimensions of our relationship have always been very, very limited. I could go there and meet Fernando in this shabby visiting room, under the scrutiny of some guard for an hour at a time. Under these conditions, I guess we did remarkably well. Fernando was always polite and soft-spoken and he welcomed me into the visiting room as though I were visiting him at his home, which in a sense I was.

Our relationship was very surface for a while. I would take him a sandwich or lobster salad and some cigarettes and have polite discussions about the weather. Then someone suggested to me that Fernando might be a chess player, and there was a chess set in the visiting room. We started to play. He was a competent player and I was a beginner, and he loved always winning. It was over these chess games that much of our early work got done. The routine became for me to arrive and for Fernando to eat his food, then we would have a game. The guards got used to the sight of us with our heads bent over the chessboard and they soon became bored and ignored us to watch tv. They were still in the room, but Fernando and I had left the room and entered the board.

It became Fernando's custom to introduce topics of discussion before he made his moves on the board. It would be his turn to move and he would look up at me and say something about AIDS or death or sickness or his wife or whatever was on his mind at the time. I viewed the chess game as a vehicle for our discussion. Eventually I got tired of losing and bought a practice board and a couple of books, and we really started having some good, long, close games and becoming friends at the same time.

Fernando began getting sicker. His mind was fogged by medications and he was at a competitive disadvantage. But by that time we had established a genuine bond and we really didn't need the chess. Still, I do miss it.

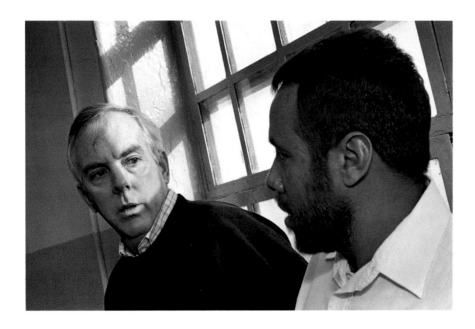

Fernando was sick for months with a variety of infections. I had the sense that he might not last for long, so I started to force some issues. We talked about many things. I have been continually frustrated by Fernando's inability to tell me all the facts about anything. He is a criminal and he acts like a criminal. He is a con and he acts and thinks like a con. I don't like that part of him at all and have never gotten comfortable with the fact that he doesn't trust me enough to tell me the truth. I really don't know if he is even capable of *recognizing* the truth.

After being on that tiny hospital ward for twenty-one months, the court ruled that inmates living with AIDS could no longer be warehoused there. They had to be mainstreamed back into the prison population unless their health status required that they be in the hospital. His health had improved by this time, so Fernando was transferred to a maximum security institution that was an hour and a half away. But it was immaculate compared to the hospital. He did well for a few months, then had a series of recurrences of pneumonia. Each time he was moved back to that awful hospital ward, then

back to prison when he got better. Finally he was taken from the prison unconscious and put on a respirator. By this time I had been visiting him for at least two years, but since I'm not a family member and the prison system is such a bureaucracy, no one called to tell me. I drove all the way there on my regular visiting day and was told that he wasn't there, but the guard wouldn't tell me where he was or how long he had been gone. I think they were afraid I was going to get my gang together and break Fernando's skinny sick ass out of jail, spirit him away to our own private hospital, and assume the care and feeding of Fernando.

Anyway, I found him in the intensive care unit, unconscious but still being watched by two guards. The doctor recognized me and told me Fernando had less than forty-eight hours left and that if I knew where his family was, I should go get them, which I did.

I can't say that the scenario was unfolding according to my script, but it did have all the elements of what I equated with being a Buddy. My Buddy was sick with a terminal illness and I was there for his support, doing for him what I could. I had been doing that for a long time, and now the relationship was coming to an end in a predictable manner. Fernando was in the ICU with tubes in him and everything looked like he would not walk from the hospital back to the prison this time. And yet, seeing him on that table, I wasn't really getting the feeling that he was leaving. He didn't look good, and the doctor kept saying the time was near, but the doctor didn't know him like I knew him. Fernando just didn't look like he was ready to give up.

On the fifth day, when I arrived, he was sitting up in bed. Mentally he was absolutely out to lunch, but he was sitting up. He was there for the next four months, recovering from the pneumonia and then post-pneumonia infections that he picked up at the hospital. I kept feeling relieved that he recovered, but I also kept waiting for the other shoe to drop. I mean he has AIDS, he was a drug addict, he had had bacterial and PCP pneumonia more times than I can remember, he was taken out of the prison in a coma and put on a respirator for five days, then he spent four more months in the hospital.

That was a year and a half ago, and at the moment, Fernando is well. He hasn't had a serious illness since being released from the hospital. We've now been Buddies for almost four and a half years, and it's a challenge being a Buddy to someone in somewhat of a permanent holding pattern, living with AIDS as a long-term illness.

Fernando is still in prison. I still visit him every week and we still talk on the phone a few times a week. I am still his Buddy, but I'll tell you, it's not the same when the person is well. My concept of what Buddy work was going to be was that I was going to work with drug addicts who have AIDS, and my role would be to help them in their struggle to come to terms with the fact that they were going to die, then to help them with the reality of their illness and death. Sometimes I think I am trapped by the fact that the only way for me to get what I want out of this is for Fernando to die, and in reality, I don't want that to happen.

But I also know that this isn't very satisfying. Fernando has entered a state of denial. We don't talk about his HIV status anymore because our visits are in a crowded room and he is paranoid that someone will overhear us talking and deduce that he has AIDS. The prison population is about 8 percent HIV-positive, and drug users are about 20 percent HIV-positive, but inside the prison, as everywhere else, it is a shameful thing to have AIDS. It has to be kept a secret. The prison environment is like living in a very crowded fish bowl; the people have nothing to do but watch each other and talk about what goes on. I can't think of a tougher place to have AIDS.

I've been doing this for so long, I think I'll just stay with it to the end to see how it comes out. The experience is teaching me patience. It's certainly not teaching me the things I thought I would be learning, but maybe that's part of the lesson.

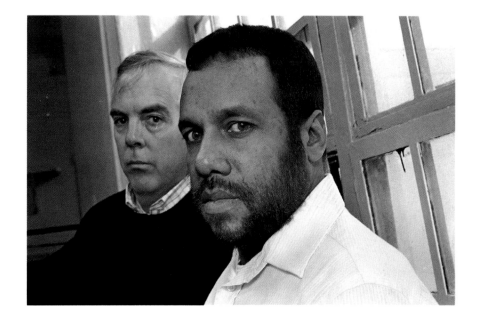

Ever since John has been my Buddy he has been a great factor in my life, with the love and the time which he has given me during my long illness. The Buddy program is very important to me and to others. It has helped me live; it has shown me what friends are for and the kind of love that people have for those who have been touched by AIDS. It has been a treasure for me. It has taught me about a team – that's what the Buddy program means to me. Love one another. My Buddy John has been a great relief for me with my thoughts. The Buddy program is successful. Thank you.

Carol & Jack

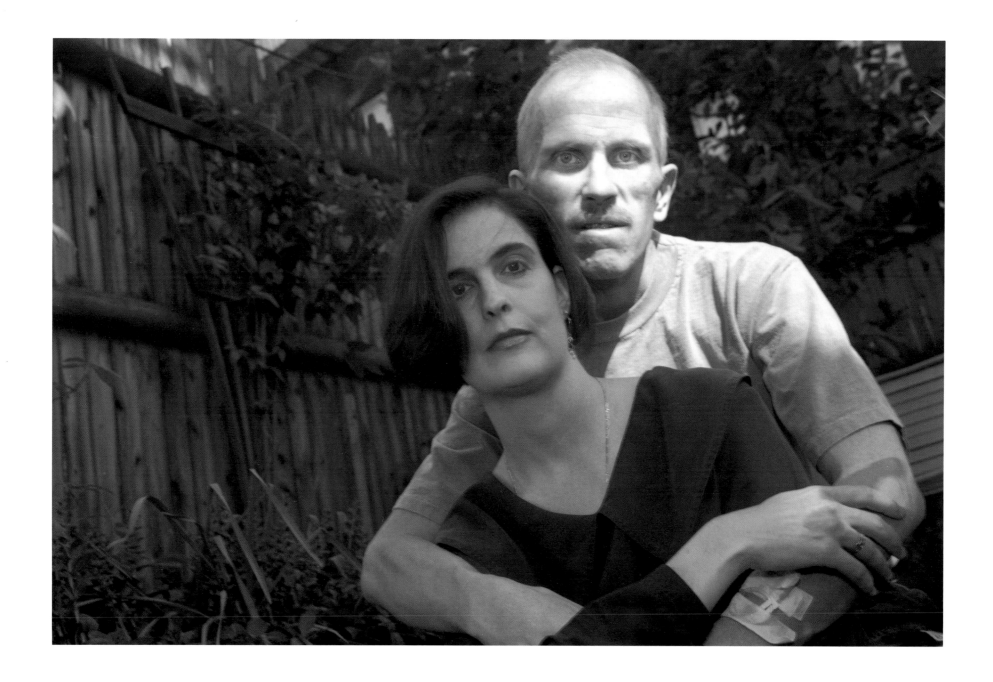

I have a cousin whom I'm extraordinarily close to who is gay. It occurred to me that because he lives across the country, if he should ever become infected, I couldn't be around to care for him. So I guess I thought of having a Buddy as some kind of cosmic credit…that if I helped someone here, and if anything should happen to my cousin, someone would be there for him. I think that's what brought me to the Buddy Program.

I was given Jack's name and we decided to meet for lunch. We were trying to figure out how we would recognize each other at the restaurant, and he said "Look for a man who's thirty-seven and looks gay," and I was thinking to myself "What does that mean?" So I said "Okay, and you look for a tall woman who looks heterosexual."

We managed to find each other somehow, and over lunch we decided to start off the relationship slowly. He was physically well, had a very busy social life, and didn't really have any immediate need for me. We were just going to gradually get used to each other.

When he was diagnosed with Kaposi's Sarcoma of the lung a few months later, the relationship necessarily changed overnight. That's one of the very last things a PWA wants to hear from a doctor. We started spending a substantial amount of time together and on the phone. He suddenly wanted me to be there for everything – doctor's visits, chemotherapy, everything. And at his house whenever I could be.

After that, Jack was never well enough for us to do much together outside his place or the hospital. Once, though, his brother brought him over to my apartment because he wanted to hear my piano. I cooked him lunch, then he was lying on the couch waiting for me to perform for him. I'll never forget him there, in his baseball cap because he was embarrassed about the chemo making him lose his hair. I played three or four Chopin tunes and when I finished, Jack was absolutely silent and still. I thought he might have fallen asleep, but eventually he turned his head, looked at me and said "I think this is the way I'd like to die." I thought at the time, and still think today, that that may be the nicest thing anyone has ever said to me.

He also had a remarkable sense of humor. Once he took me and eleven other friends and family members out to dinner. He had rented a limo, and we all had champagne and went to a wonderful Italian place. It was a marvelous night, and though it completely wiped him out for days afterward, it meant so much to him. The following day I started a new project, in the course of which Jack became concerned about my lack of sleep. Once he called and said "I'm worried about you, Carol. Would you please take care of yourself? I want you to be at the funeral." I said "Jack, stop!" And he said "Well I'm serious. If you think that dinner was great, wait until you see the funeral!" He never lost that outlook.

Jack started referring to AIDS as the "disease of the week club," because from one day to the next there's always the possibility of some new illness or symptom. Nothing remains constant. How he coped with that, I just don't know – and maintained a sense of humor and a genuine concern for the people he loved. It sounds trite to use the word "inspiration," but that's really what he was. With all he was enduring, he still said things like "I am just so lucky," referring to his friends, family, and me. It's hard to imagine.

My Buddy died in an unexpected way – his mind just went. Literally, one day Jack was still inhabiting that thin little body, and the next day the body was vacant. He was moving into a hospice that morning, and when I talked with him, he sounded like himself – perfectly lucid and intelligent. His home health nurse was going to accompany him and get him settled, and I told him I'd be there later that afternoon. By the time I arrived, the difference in him was astonishing. At times, he didn't know who I was, and he thought he was in an English bed-and-breakfast inn. All in all, not a bad place to be, I suppose.

The next day, he could barely speak. He just gradually drifted off into some unknown and hopefully celestial place, and died early that evening. It seemed uncommonly peaceful and, under the circumstances, right.

What happened after his death was difficult to take. Things he had felt strongly about weren't carried out. I see this so often – families are terrified to respect the wishes of the person with AIDS because of society's attitude toward the disease. The evolution of people's perception of AIDS has been excruciatingly slow. The PWA may want people to know that he had AIDS, but the family feels it necessary to have the obituary read "died after a long struggle with cancer" or something of that sort. And Jack wanted very much to be associated with this project, but his family was so afraid of the reactions of others toward them, they asked that I rescind my permission. I couldn't. I knew it was what he wanted, and though I care deeply about them, my primary obligation is to him. They loved him very much, just as he loved them, but like so many others, they were afraid. To me it feels like the final and perhaps the ultimate indignity.

Regarding the relationship itself, all I can say is that it worked. And it meant more than I can express adequately. It started out slowly and naturally and developed into something meaningful; in certain moments, profound. I would have done anything for him. To protect him from the fear I saw in his eyes more and more. People enter Buddy relationships perhaps with the *hope* but certainly not with the *expectation* that a real closeness will develop. That's a bonus. And I feel so blessed that it happened that way for us.

There are still times the phone rings and I expect it to be Jack, then it dawns on me once more that it won't ever be him again. I don't want to romanticize this or make it more significant in death than it was in life. It wasn't a perfect relationship; it wasn't the most important I've ever had. What it *was* was a genuine friendship and a constant inspiration, in the truest sense. I remain inspired by his courage and faith. I marvel at the fact that in spite of the horrible things that were happening to him, on a daily basis, he could maintain a love for his life and the people who shared it with him. He never gave up. Most of all, however, I am honored that he chose to allow us to become real friends, rather than keeping me as a "convenience." That happens in Buddy work and it would have been fine, but it wouldn't have been nearly as wonderful, for either of us, as the way it turned out.

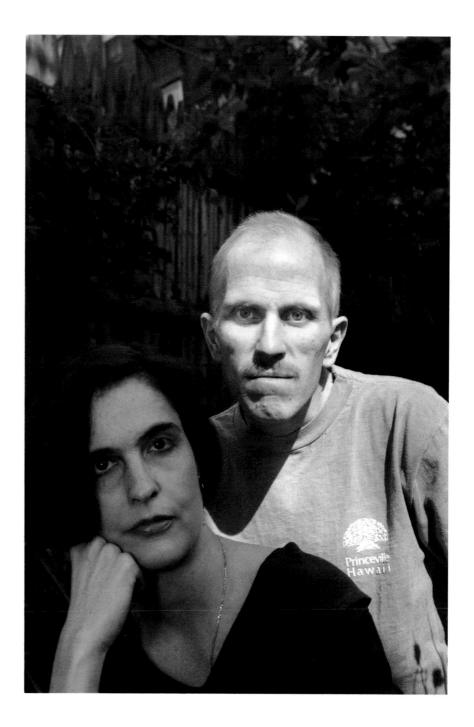

Monte & Jay

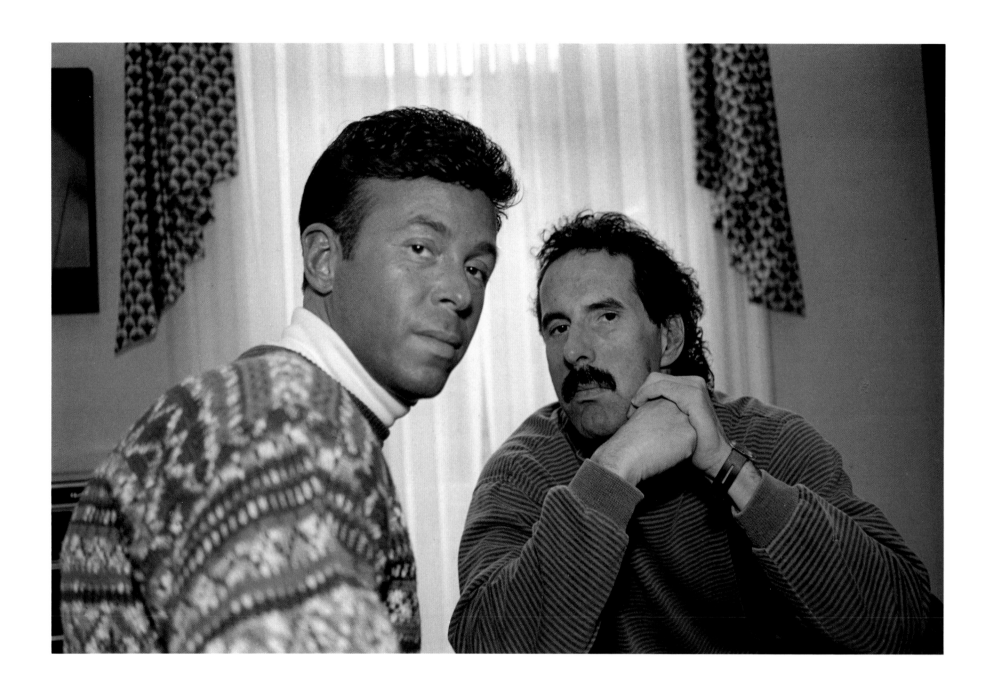

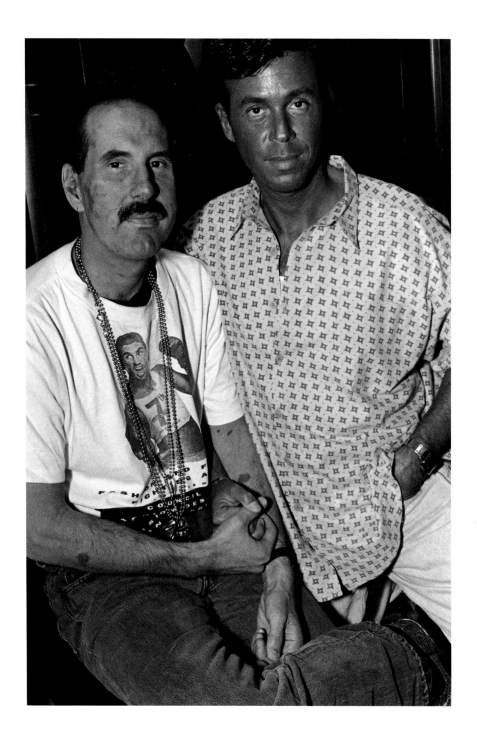

I became a Buddy at a point in my life when I didn't know anyone who had been affected by HIV. Now I know many who have. But I've always felt fortunate and wanted to give something back, and I'm not an envelope stuffer. I wanted something one-on-one. Very intimate. I wanted to sit and help and talk.

It's painful and sad, and we wish we didn't have to think about this, but there's no other experience like it. You look at the world with different eyes than you had before. I'm not sure what my expectations were going into it, but witnessing this horror has changed my life forever. It is devastation I couldn't have imagined. I never really thought of myself as being immortal, but I feel so much more mortal now than ever before.

I honestly can't imagine what it was like in the world without AIDS. It's hard to remember that time. And at this moment, I can't imagine it will ever go away.

Being a Buddy is a very special role. It enables you to participate in something incredibly intimate: the last stages of someone's life. "Buddying" used to mean something different: knowing someone for two or three months, then he was gone. Now people live longer. On so many levels, that's a blessing; on a certain level, though, it's a nightmare. Buddy relationships are much more long-term now. So even though you go in with a certain amount of emotional detachment, you do get connected. And you don't want to; at least I don't want to. For my own sanity, I want to stay detached, but it's impossible. You meet when a lot of their defenses are gone; their facade is peeled away and you see them in a way that's very intimate. You meet people that – at least in my case – you probably otherwise would never have met, or become friends with, or had any real connection with.

I think Jay wanted a Buddy so he'd have someone he could talk to with no expectation of reciprocation. With friends, you tell them your problems and they want to tell you theirs. But our relationship is not really an exchange. Very little information about my life is shared, and I think that's what Jay wants. Actually, it makes my role a little easier

because the boundaries are so well defined. He'll call me and be really down about something, and he knows I'll focus totally on what he's saying. I won't bring in things that are going on in my life and bothering me. He can dump on me, then say "See you later" and hang up, with no reciprocation. I think he also doesn't want to burden his friends when he wants to talk about something connected with the illness, which is where I come in. That's a special gift that I give him.

And I didn't know him when he was "better looking"; I entered at a point when he was already looking sick. So as this progresses, he isn't self-conscious with me the way he is with people who knew him years ago.

Jay is a character. He's stayed in control of his life as much as he possibly can. His matter-of-fact style about planning his funeral is incredible. There are times I'll be lying in bed in the morning and just flash on Jay's funeral for some reason. He's planned out the whole thing from beginning to end, almost like a social event, except that we won't get to talk with him afterward to see if he views it as a success. He goes on and on about it, and it's hard to listen to sometimes. He's so "okay" with it, and maybe I'm uncomfortable for that reason. Because he *is* so okay. It doesn't feel like anyone should be – not at the age of thirty-six.

Something I'm amazed at is the support he's given. Jay has a large Italian family and wonderful friends, which makes my job easier. You witness, at a time like this, those friendships really being there, and you realize that this person obviously was a good friend to these people. It's sad to see people dying terribly alone because they weren't good friends to the people around them. Lots of people are dying alone.

But being a Buddy, especially in those cases, is incredible. You're the only game in town. My first Buddy was a straight man with a wife and kids, living in suburbia, and he was really rejected by his friends and family. I was his only support person, and that's a much harder role to fill.

I've seen Jay deteriorate significantly over the last five or six months, and it's very hard. It reminds me constantly of my own mortality. No one lives forever, and though I know that on an intellectual level, there's something about *watching* it that really makes a difference. There are times I dread seeing him because I don't want to be reminded of it.

I feel like I'm burning out a little. I don't mean with Jay, because he's careful: he says he doesn't want to use up all his slots on my dancecard yet. But I'm feeling that way because even though I work toward a certain amount of emotional detachment, it's hard to maintain it. You always walk away feeling good, bad, sad, tired, like you've accomplished something, all kinds of mixed feelings. But the bottom line – the main thing you leave with – is an incredible feeling of sadness. It's like yeah, you made a difference, you did what you were supposed to do, but the person died. The operation was a success, but the patient died anyway.

Jay will forever be imprinted in my mind. I'm thankful for the opportunity I've had to know him, and for the blessing of his being so open and honest. Letting me into this personal, private part of his life. Because dying *is* a part of life; it's just the *last* part.

At the same time, it's a gift. I feel like I *give* a gift, but much more than that, I *get* one. Because sharing that time with someone, the last days of their life, is an incredible gift. It's touched me in a very personal way. As sad as the loss is, the feeling that someone invited me in to share something so intimate has had a tremendous impact. I would do it again in a minute.

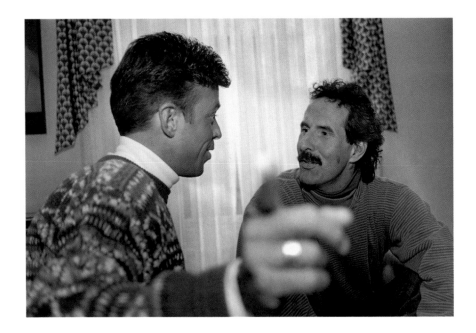

When people ask what it's like to live with HIV, I explain that it's like living with a roommate from hell. Some days you seem to be okay and able to work out your differences. Other days it drives you up a wall and is extremely difficult to manage. The best I can do is to learn to co-exist with the virus rather than always doing combat with it. It's there, it's living with you, and it's not going to allow you to do everything you want, when you want, and how you want. It's going to rear its ugly head and remind you, in both physical manifestations and emotional responses, at the most inopportune times, that you have AIDS. And having AIDS means your life is different.

Another way I explain it is that it's made my life better. It's been an opportunity for me to become a more honest person — with myself and with others. It's allowed me to live a little less cautiously and not be so worried that I'll get hit by a truck, or that if I spend too much money, I'll go broke. I've gone after life very aggressively since I've been diagnosed. The disease really forced my hand.

My life is very small compared to what it used to be, and my issues may seem insignificant compared to other people's. When something in my apartment breaks, for example, I want it fixed right away because that's all I have to think about. It's because I can't fix my disease that I try to make everything else around me perfect. I think if I buy more things, everything will be okay. If I go more places, everything will work out. A lot of people don't understand that — the need to have control and to make it right.

And time is important in a way that it never was before. When people say "Let's get together" and leave it at that, it tells me they don't really understand. I need the date, and it needs to be soon. I want it *now* because I may not have tomorrow to have it, or be well enough tomorrow to do it.

It's frustrating going to a doctor and not being able to get an answer of any certainty. Everything is "If you do this, this might happen," or "If you don't do this, this might not happen. We don't know either way." So there's a lot of uncertainty that plays into an emotional need to have certainty in my life.

One of the things I really like about Monte is that he has connections and power, and when you're a person with AIDS, you're not in very much control of what's happening to you. To know I have an ally who can make things happen makes me feel very enfranchised and fortunate.

We're a lot alike, Monte and I. We have similar aspirations; we have the same nature. If I am to have a Buddy at all, it has to be Monte. He somehow managed to come into my life without infringing on my pride, my self-respect, or my dignity. He's been able to help me without making me feel dependent or needy. I can trust him completely. I know he's heard what I've said, whether or not I've actually articulated it. He understands.

I feel comfortable revealing what I want to happen when I lose control of my faculties or my body. Monte has been available as a sounding board, and has supported me in the things I've chosen to do as my illness gets worse.

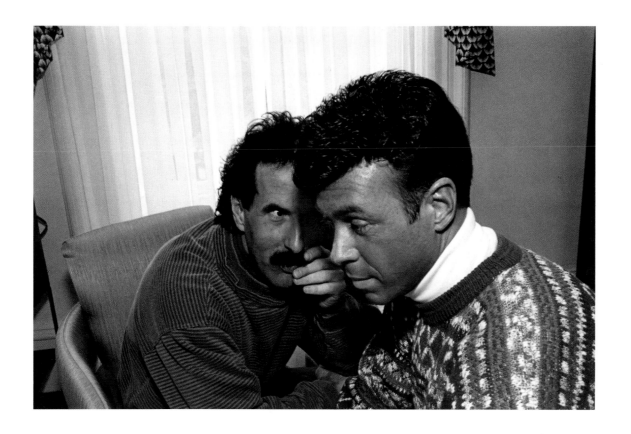

The stage I'm at right now is that I need quiet as much as possible. To disconnect. To limit my exposure to the outside world. So many people invade my privacy as a result of the disease and my need to access so many services, that I just don't want this continual barrage.

Monte, unlike anyone else in my life, understands all I've just said. His ego isn't involved. He understands when my phone is off the hook, and it's okay if I don't return his calls. He has learned through other people's experiences – he has a support system of his own. And that allows me to not have to help him with it, while other people in my life haven't gotten it together to go out and get a support group, so they want to process it with me. I don't want to process it with them.

You realize at some point that any bargains you've made haven't made any difference. You get near the bottom and say "It doesn't matter if I go left or right, it's not going to get any better. I'm still going to die."

But Monte is prepared for that. He fills a role that no one else can. He does this simply because I'm a person trying to live with AIDS and, eventually, die with AIDS. Other people have other relationships with me. They were something to me before. Monte is just this to me. He's the person who's in my life for this reason. And I think that's really the uniqueness and the importance wrapped into one.

THE BOYCE FAMILY

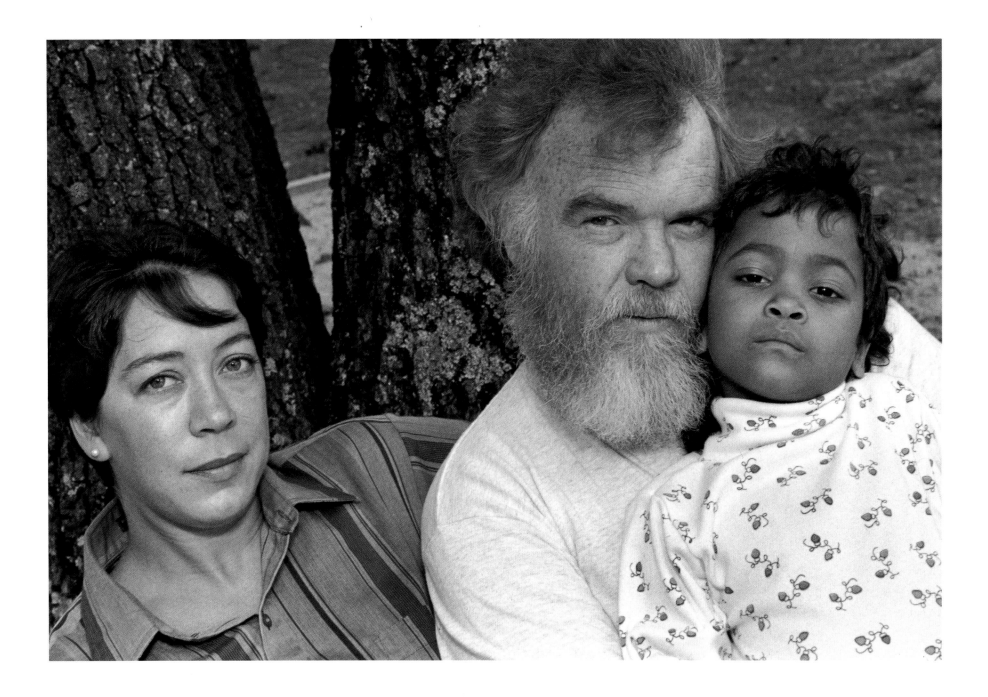

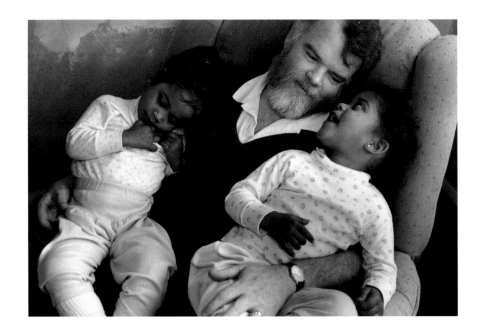

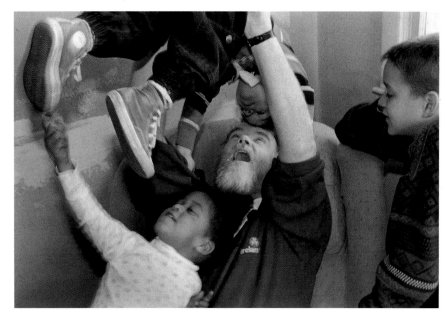

"**B**rianna, do you know who Magic Johnson is?" "Oh yes," the tiny girl answers. "He has special blood, like I do."

Brianna's "special blood" is HIV-positive, inherited in the uterus from her mother. She also has a full-blown AIDS diagnosis. And she just celebrated her seventh birthday – a milestone none of the specialists predicted she would reach.

But there's no question – so much more than blood is special about Brianna. About her entire family, in fact.

In 1988, John and Sharon Boyce had reached the end of an exhaustive effort at having their own natural family. Rather than going through conventional adoption, they went to the State of Massachusetts' Department of Social Services (DSS). There they began a training program through which children are placed in pre-adoptive homes.

The class was told about a little boy born to a mother who was HIV-positive. And because infants are born with the immune system of their mother, this one had the HIV antibodies. At about the ninth month, the child begins to develop his or her own system and, within twenty-four to thirty-six months, either converts to HIV-positive or reverts to HIV-negative.

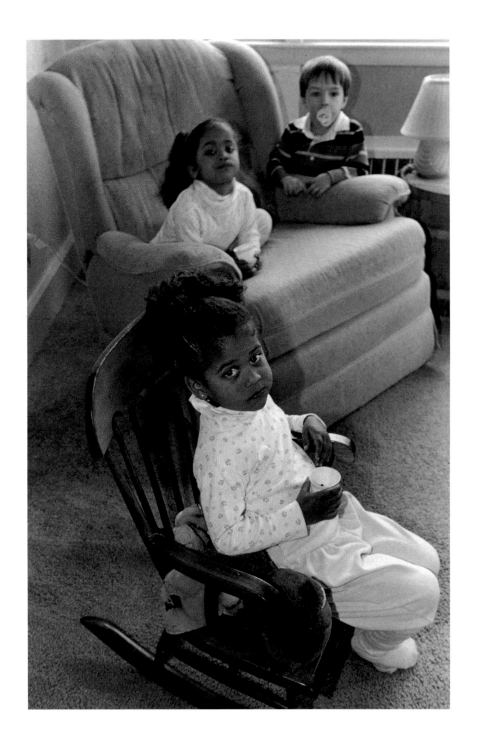

But this baby needed a home immediately, and John and Sharon had to make a decision based on his uncertain HIV status.

Very little was known about pediatric AIDS at that time. And neither Sharon nor John had any knowledge about the virus. To educate themselves sufficiently to make an informed decision, they called on the HIV Team at the University of Massachusetts Medical Center (UMass), where they received a crash course on the potential impact on their lives should this child develop AIDS. By the time the class met the following Monday night, the Boyces had made their decision: they wanted the baby.

If the presence of the HIV antibodies didn't complicate things enough, the little boy also inherited an addiction to heroin. The first three weeks of his life were spent in methadone detoxification. Then Sharon and John were able to take him home, and with Brian, or "Beamer," the family started to grow.

When Beamer was only eight months old, John and Sharon received a call about two sisters at UMass – social admittances. Brianna, who was nearly three years old, already had AIDS; her sister, Felicia, was fourteen months old and (like Brian) had been born with the HIV antibodies. Thus far she had tested negative and was expected to be cleared after twenty-four months. The girls were about to be separated. Brianna would be institutionalized until she died; Felicia, who was considered adoptable, was expected to be placed in a pre-adoptive home. The Boyces were told that the girls were extraordinarily close. Their mother was a cocaine addict, unable to care for herself or her children. Through numerous moves and foster-care placements, the girls had had only one another. Now even that tiny bit of security was tenuous.

John and Sharon immediately called DSS and said they wanted the girls. But they were informed that these were mixed-race children, and DSS was opposed to placing them with the Boyces because they felt the small town where the family lives wasn't ready for that. "That's really too bad," said Sharon, "because we are." Eventually they received a phone call saying that they could pick up the girls, though initially it was considered

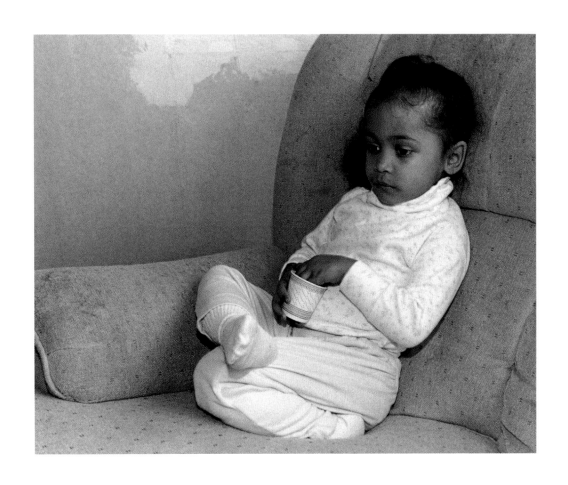

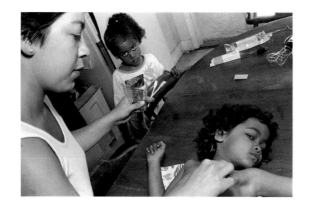 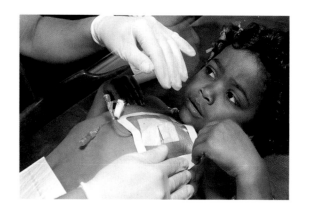

a foster-care placement and, therefore, temporary. Still, Sharon and John were elated. The girls, at least for the moment, had a home.

John and Sharon viewed taking Brianna and Felicia with less hesitancy than they did taking Brian. Was it easier with a child they were certain had AIDS than with one who might develop it? "I don't know if it was easier," John says, "but the decision was made for different reasons." Beamer came into their home for what John calls selfish reasons – he and Sharon wanted a family. The girls were taken for what he terms humanitarian reasons – the thought of separating two sisters who had always had only each other was inconceivable. Also, by the time the girls came along, the Boyces were educated about AIDS. The fear factor was gone.

But there was more. When, in her sleep, Brianna began crying out for Joey and Jeremy, Sharon and John learned that the girls had two half-brothers. Not long after that, Brianna was hospitalized and her biological mother brought the boys to see her. At the time, they were in foster care, but both eventually ended up visiting the Boyce's home for about four months. And while Joey remains in a group home, Jeremy (at the age of fifteen) subsequently became the next member of the family. Within a period of only thirteen months, the number of children had grown from zero to four. As John puts it, "It's really the only way to have a family. All the stretch marks are limited to the MasterCard and Visa."

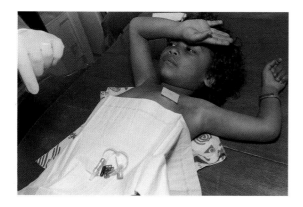 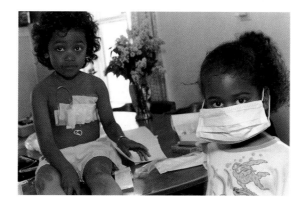 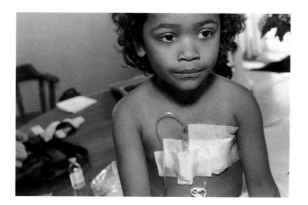

Why would anyone take such a chance? Why risk growing to love a child you know you're going to lose? Sharon explains their view that there simply are no certainties in life. "Everybody is terminally ill. People don't usually look at it that way, but it's a fact. All that's guaranteed is right here, right now. We were willing to accept that with Brianna."

She continues: "I don't dwell on any of this daily. I don't fight reality. A lot of people do, but I don't. Sometimes my eyes mist over, but certain things in life just *are*, and nothing you do is going to affect the outcome. There is no way to change the inevitability of Brie's death, and this family has way too much to do every day to invest a lot of time in worrying."

When Beamer and Felicia were both cleared of the HIV antibodies, that left only Brianna's healthcare to coordinate. The family made the decision to take on as much of it as they could, to keep Brianna in her own home rather than in the hospital whenever possible. And her care is literally a family endeavor. Sharon learned how to access Brianna's portocatheter – a "permanent" catheter implanted in her chest, because the veins in her arms are depleted – to administer medications. Jeremy and Felicia know when something is wrong with the i.v. machine and can shut it off until

they get one of their parents to fix it. And Jeremy sometimes has taken over giving Brianna her oral medications when, says Sharon, "I feel too tired to climb those stairs one more time that night."

The medications have consisted of a host of things. For a period, there were infusions of gamma globulin (a boost to the immune system) every twenty-one days. During this four-hour infusion, Brianna could play and do virtually everything her brothers and sister were doing, wearing a small backpack that administered the medication. And she has, at different times, been on the three antiretrovirals for AIDS – AZT, ddC, and ddI. All presented adverse side effects that eventually became intolerable. Each ate away the lining of her stomach, making it impossible for her to consume anything except water or milk without severe pain. She became a "Rolaid junkie," says Sharon. She left for school each day with one tablet in each hand.

Sharon finally had had enough. She went to the doctors and said "No more. I would rather have her die being able to eat than to die not being able to keep anything down." Brianna was taken off the medication in mid-December 1992 and told that by Christmas she would be able to eat anything she wanted. By Christmas, she could.

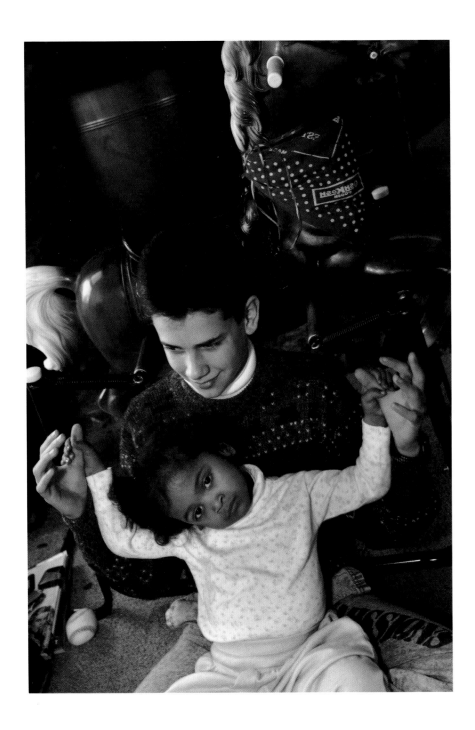

The most obvious outward sign that Brianna's system isn't like that of most children her age is her diminutive size. In spite of the fact that she is about two years older than her sister, she is smaller and appears to be the younger of the two.

For much of her life thus far, Brianna has been relatively asymptomatic, which Sharon and John attribute to the fact that the family has always been very proactive in her medical care. Others see the love and commitment the Boyces share and can't help believing that Brianna's health has had more to do with simply being a part of this family. She is treated like the other children – encouraged to go as far as she can go, and taken care of when she's unable to go farther.

An article about the family was printed in the local newspaper in February 1991, relating in detail Brianna's illness and the other children's histories. The Boyces waited for a reaction. Sharon and John remember a police car tucked discreetly behind a building across the street for some time. Sharon wondered if the community pool would empty out when Brianna jumped in. Instead, people called up expressing happiness that the children had a home. Letters arrived with offers to babysit; nurses volunteered their services. And there was a woman in town whose son had died of AIDS. She finally had someone to talk to.

For a great many people, Brianna Boyce gave AIDS a face for the very first time. And what a face it is. Large eyes, dark brown hair, and a gap between her front teeth when she smiles. And she smiles a lot. She has never allowed the virus controlling her immune system to control her and her world. To her family, classmates, and the entire community, Brianna has become a teacher. The courage and strength contained in one beautiful little girl have inspired and educated many many people. She has illustrated the ultimate lesson in life: live it well. Leave a mark when you leave. And you don't have to have reached adulthood to do that. Brianna teaches those around her, and in doing that, enables them to go on teaching.

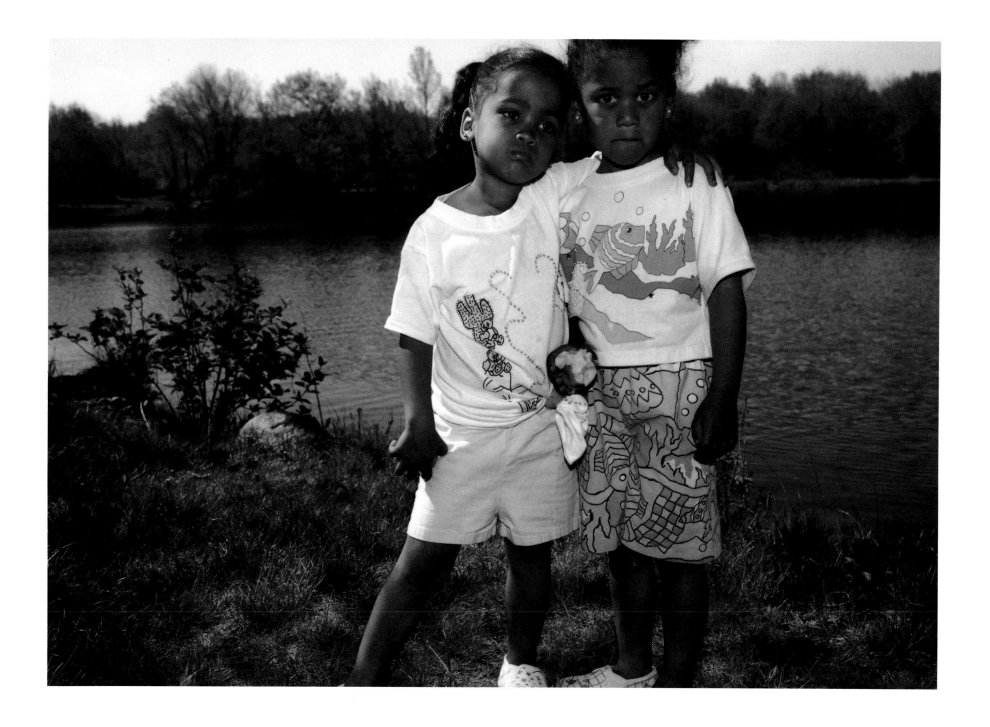

Brianna's presence was no small issue for the school department. And the issue wasn't an HIV-positive child in the classroom. It was death and dying. No textbook can prepare a teacher for telling first graders that a classmate is ill and is going to die. Brianna's teacher says the class would wonder why she'd be out for weeks at a time. She said all you can do is answer from the heart. Sometimes the entire class would be taken to a special meeting place behind the school where they could talk, question, and cry.

For the Boyces, Brianna provided a compelling motivation to begin the process of understanding a disease that is having such a profound effect on an individual, social, and global scale. That process resulted in a desire to help others benefit from what they had learned. Particularly when Brianna entered the school system, John and Sharon considered it a responsibility to educate people on HIV. They have lectured on caring for children with AIDS, saying that "With AIDS, there is everything to respect, but fear doesn't really need to be a part of it."

Even Brianna is prepared to tell others about her HIV status. When she stayed overnight with a friend, she asked the friend's mother "What if I cut myself?" She is aware that if that happens, someone has to be wearing gloves before she can be cared for, and she wanted to make sure the mother was prepared for that.

Recently Brianna's illness began to accelerate rapidly. Very simply, she is tired of fighting. She no longer attends school, the family decided to take her off all drugs except pain medication, and all her nutrition is intravenous. She weighs under thirty pounds, can barely walk, and no longer sleeps lying flat because she's unable to breathe. It is incomprehensible what it must take just for her to make it through a day. John and Sharon now feel that "We've done everything we can; the doctors have done everything they can; it's time for God to take over."

"Brie has lived a good life," John says. "Our decision to take her was based on the belief that the important thing was to improve every day for her. If we could do that, we knew we would have touched this little girl in a significant way." But he says they had no real comprehension at the time of how profoundly Brianna would touch their lives, and those of the people in their community. He and Sharon both went into this thinking "Okay, we can handle whatever comes. We won't get that attached because we know what's ultimately going to happen."

Life, of course, doesn't work that way. It isn't possible to meet Brianna, or any of the Boyces, without growing attached to them. One can't help but spend considerably more time in their home than is really necessary, just to hear Brianna pleading with Sammy, their bird, to give her kisses. To sit quietly and let Felicia apply pretend makeup. To hear Beamer asking his father if they can go have a "cocktail." And to see that look in Jeremy's eyes when he talks about or interacts with his little sisters and brother.

While Brianna has, by all estimations, beaten the odds, AIDS is still a terminal illness. How do John and Sharon handle that inevitability, particularly in relation to making it comprehensible to their children?

Not long ago, some questions were plaguing Brianna that were too painful to ask. So a puppet on her hand, named Elmo, asked for her. "Is there a God?" Brianna's mother answered that she was certain there was a God. Then Elmo asked if Brianna would be able to walk again when she got to heaven. Would her legs ever work again? "I told him that Brie wouldn't need legs because she would have wings," said Sharon. Elmo seemed satisfied.

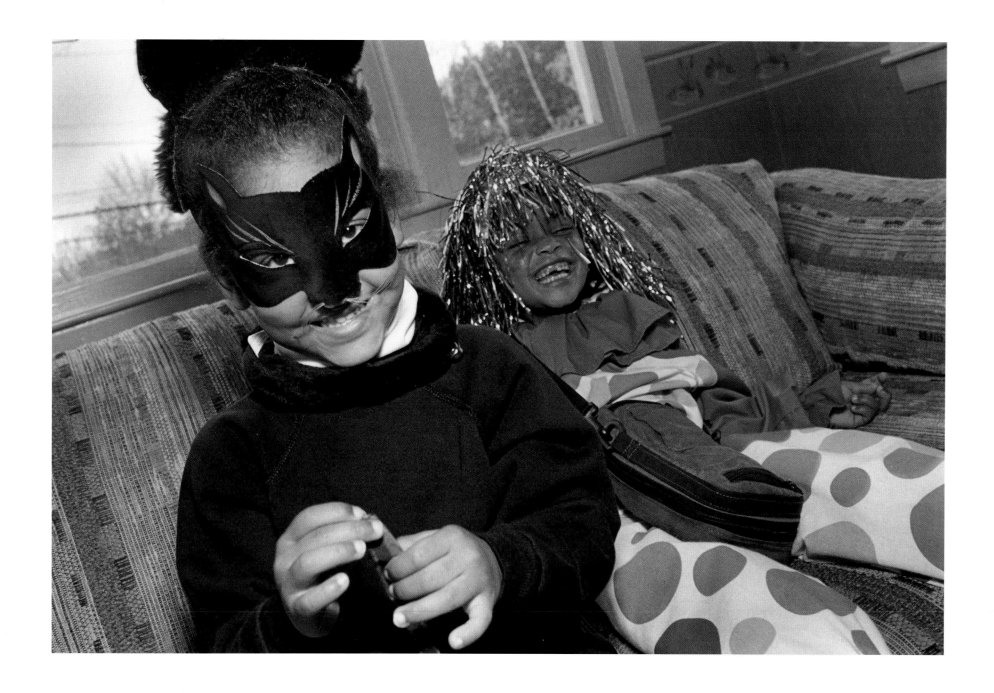

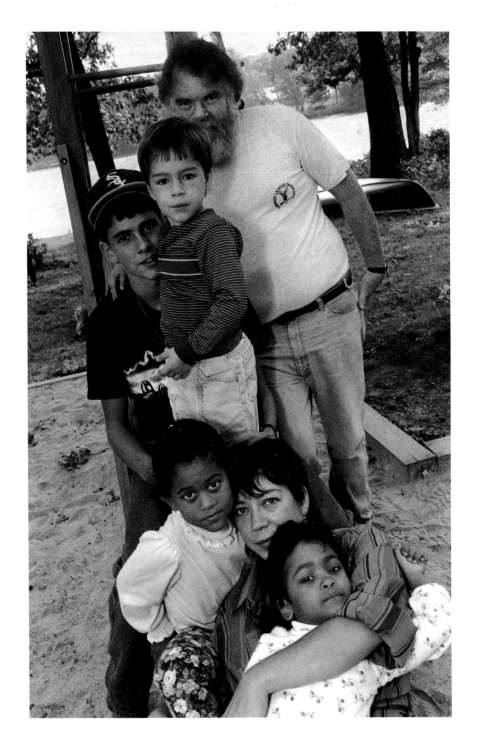

As a family, the Boyces talk openly about dying and its implications. "We don't lie to them, ever," says Sharon emphatically. "When the kids ask, we answer as honestly as we can. They have been told that everyone dies. Everyone. God just doesn't give guarantees. Some people live to be very old; others go to heaven when they are still babies. Death is just another part of life."

They've also been told that when people go to heaven, they become angels, and all angels have jobs. Their grandfather, who died a few years ago, for example, is responsible for catching balloons when they get away. John talks about Beamer running in the house one day in tears, crying that "Papa came down from heaven and swiped my balloon right out of my hand."

Brianna informs them that when *she* goes to heaven, her job will be to make it rain, because with the rain, the pretty flowers grow. Not long ago, she and Sharon were outside standing in the rain with their heads tilted back, catching raindrops in their mouths. Sharon said "You know Brie, soon God is going to need help with the rain." Brianna nodded and said "That's *my* job, mommy." "Now you tell me," says John, "that for the rest of my life, I'm going to be able to walk outside on a rainy day and not think about Brie up in heaven, making it rain."

POSTSCRIPT:
Brianna died peacefully in her sleep, in the hospital. Her mother, father, and younger brother were close by. On the way to the cemetery, a gentle rain began to fall.

Brianna Emma Boyce: December 26, 1985 – June 17, 1993

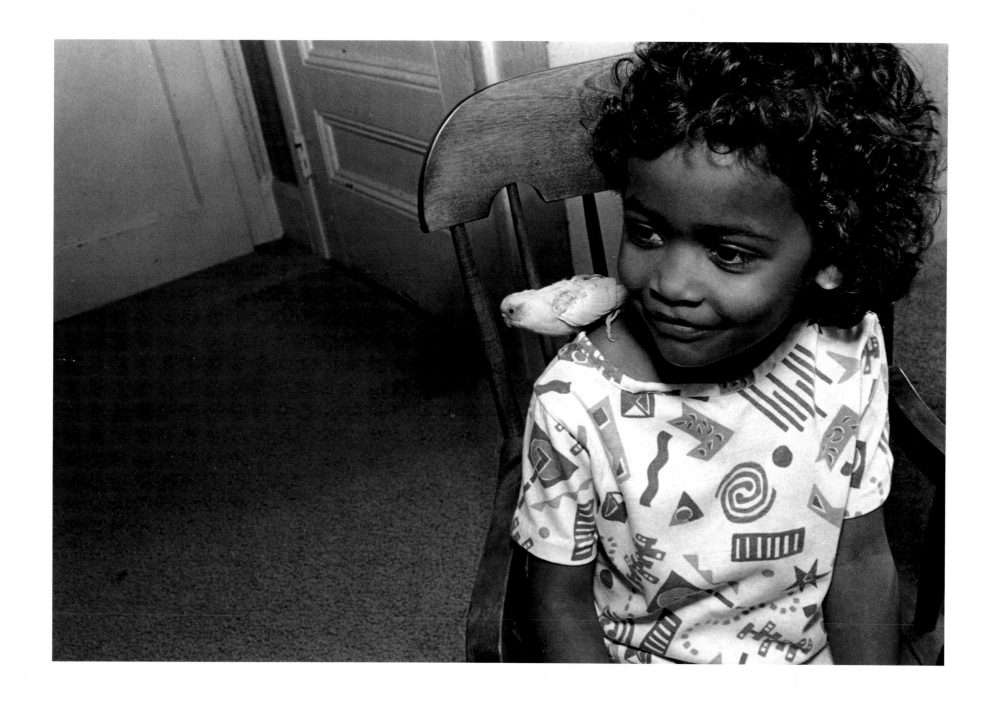